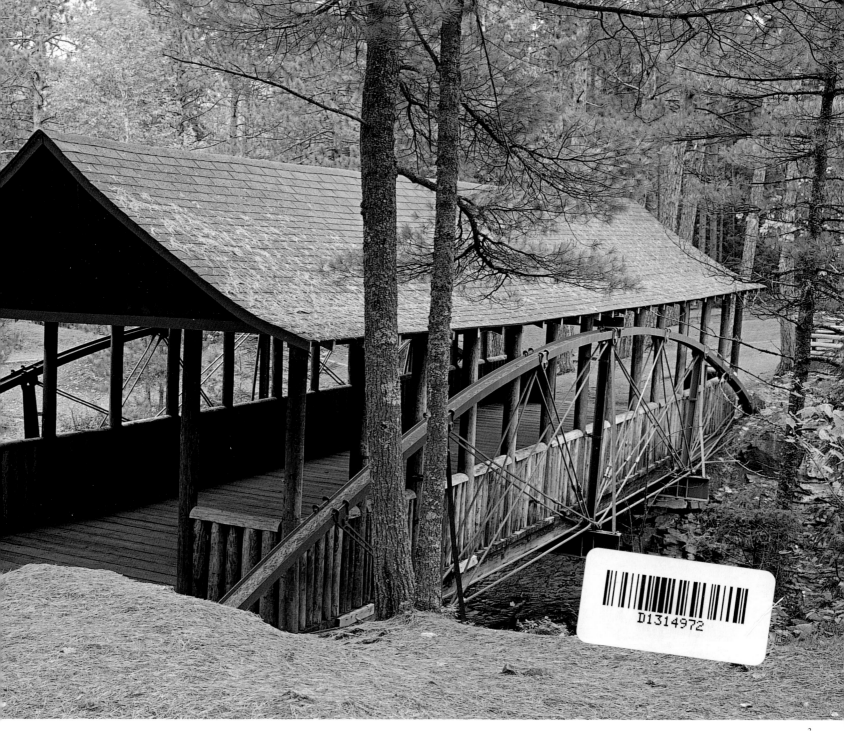

3

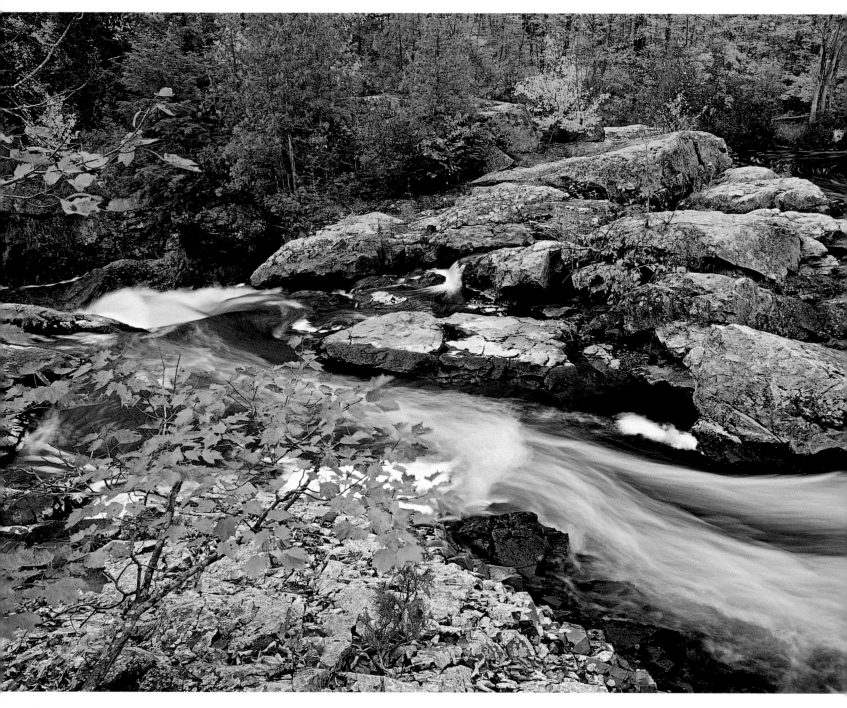

WISCONSIN
impressions

Photography by Darryl R. Beers

FARCOUNTRY
PRESS

RIGHT: This unique fifty-five-foot covered bridge spans the Amnicon River in Amnicon Falls State Park. Built by Charles M. Horton, the bridge features arched beams secured with hooks and clips instead of rivets and bolts—called the Horton or bowstring design.

TITLE PAGE: The Cana Island Lighthouse was built in 1869 on an 8.7-acre spit that juts into Lake Michigan. The Door County landmark displayed its light for the first time on January 24, 1870.

FRONT COVER: Wyalusing State Park is where the Wisconsin River (pictured) meets the Mississippi River. In addition to twenty-four miles of hiking trails, the 2,628-acre park features camping and numerous opportunities for recreation.

BACK COVER: Autumn maples rise above Keshena Falls on the Wolf River. The U.S. government's Treaty of Keshena Falls was signed here by Chiefs Keshi'niu and Oshkosh, establishing the Menominee Indian Reservation. The Menominee Indians have resided in the area for more than 10,000 years, making them the oldest continuous residents of the region we now know as Wisconsin.

ISBN 10: 1-56037-378-4
ISBN 13: 978-1-56037-378-0
Photography © 2006 Darryl R. Beers
© 2006 Farcountry Press

For more information about our books write Farcountry Press, P.O. Box 5630, Helena, MT 59604; call (800) 821-3874; or visit www.farcountrypress.com.

Created, produced, and designed in the United States.
Printed in China.

13 12 11 10 09 2 3 4 5 6

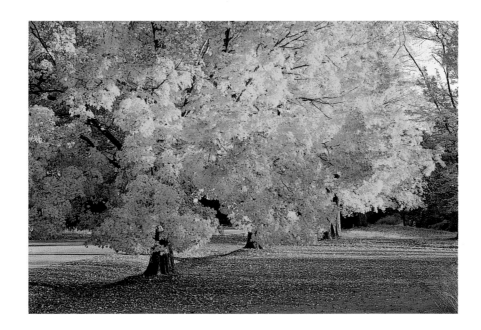

ABOVE: The sugar maple was selected by schoolchildren as Wisconsin's state tree in 1893.

RIGHT: Locals celebrate the bounty of autumn in Washington County.

LEFT: Foster Falls tumbles twenty-five feet into the Potato River in Iron County.

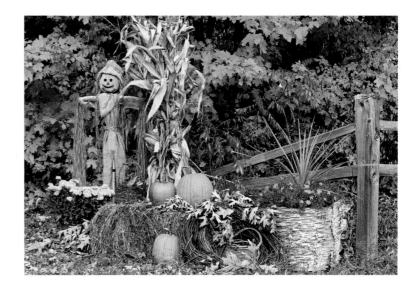

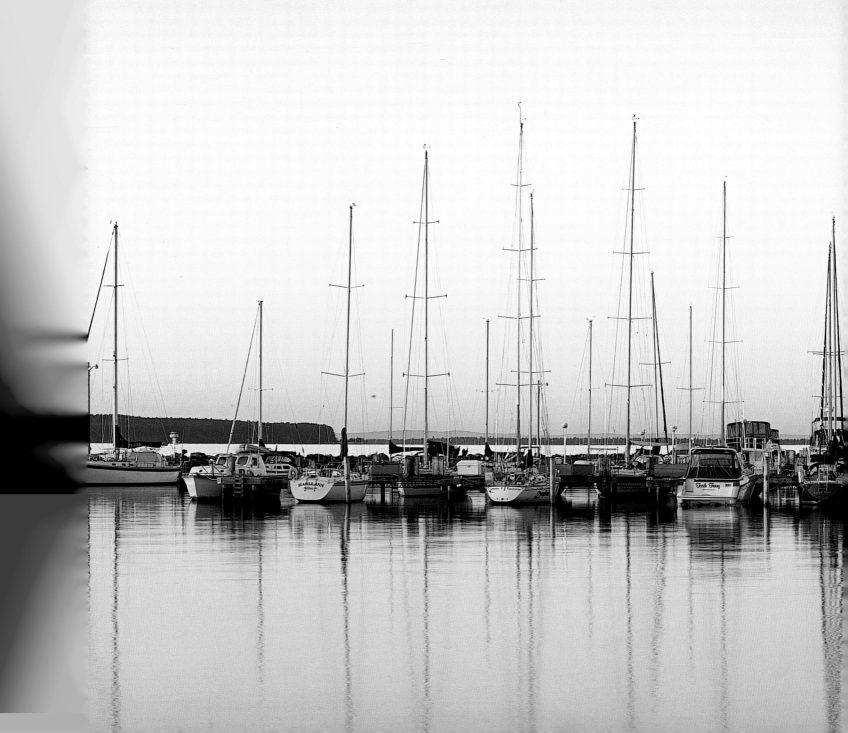

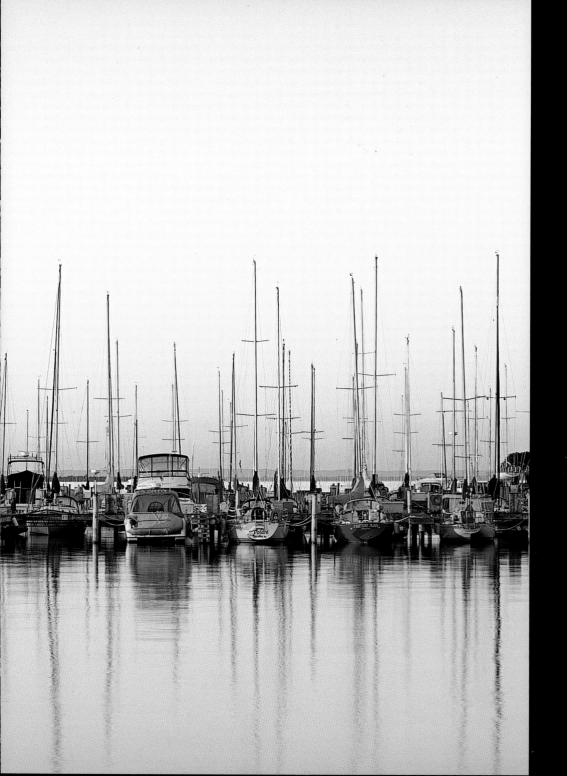

Sunrise glints off sailboats docked in Bayfield on Lake Superior.

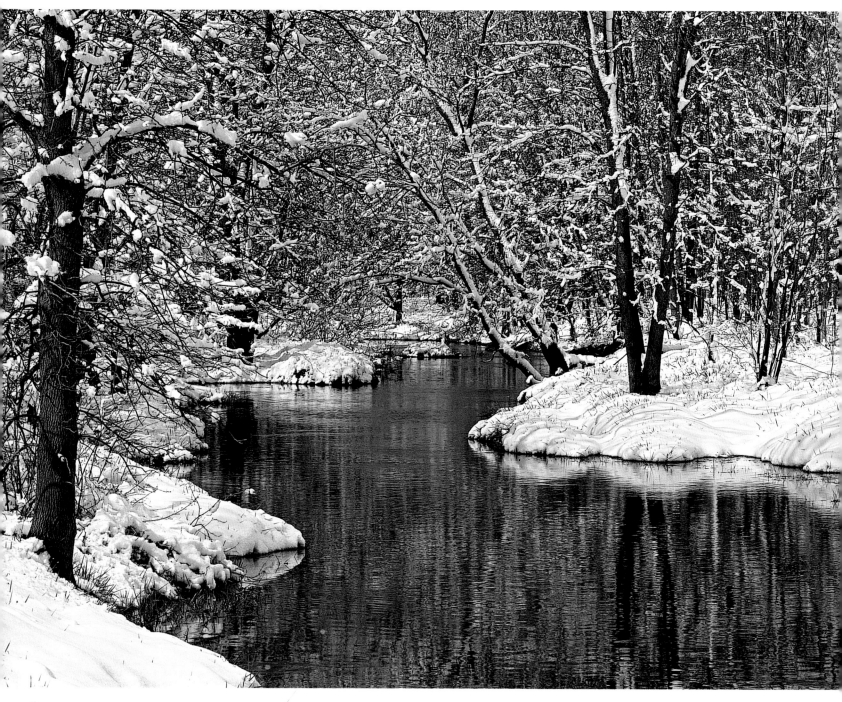

LEFT: Fresh spring snowfall turns the forest around the Kewaunee River into a winter wonderland. The name "Kewaunee" is the Potowatomi Indian word for "We are lost." Indians lost in the fog offshore in nearby Lake Michigan would call, "Kewaunee, Kewaunee" in hopes of being guided ashore.

BELOW: Tundra swans form monogamous pairs and typically share water holes or marshes with other swans. In fall, they migrate south. PHOTO BY R. J. AND LINDA MILLER

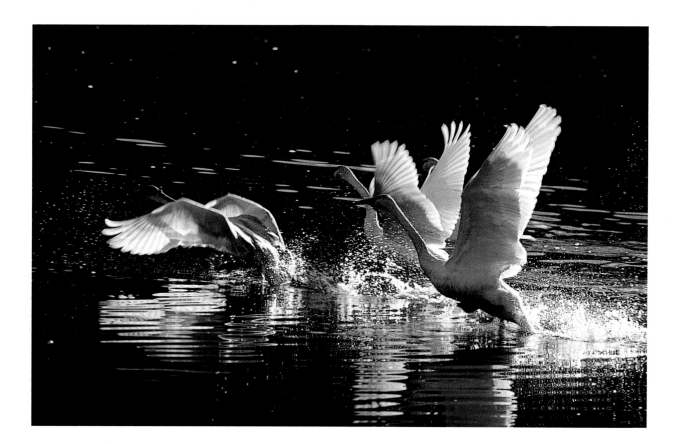

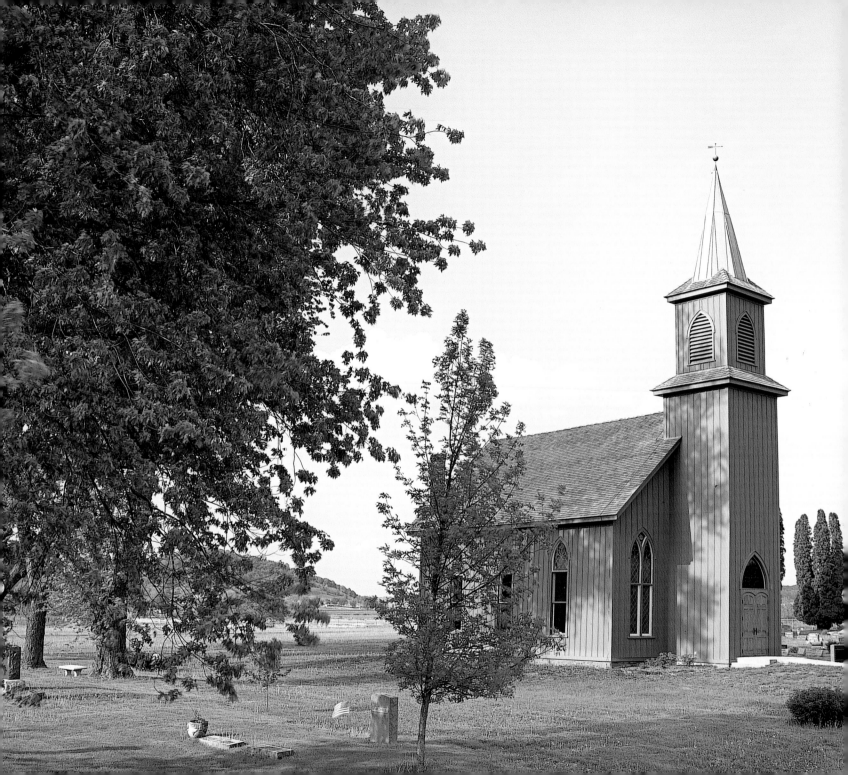

LEFT: Pioneer families built the Little Brown Church for $500 in 1875. The adjoining Bear Valley Cemetery is the resting place of some of Wisconsin's early settlers.

BELOW: The son of German immigrants, folk artist Fred Smith was born in 1886. He could not read or write, but was a talented musician and a logging legend. In 1950, at age 65, he began constructing a fanciful world of outdoor sculpture he called Wisconsin Concrete Park, featuring woodland creatures, local figures, and mythic heroes made from wood, cement, and bits of glass and metal. After Smith died in 1976, the Kohler Foundation purchased the park, restoring and maintaining the folk art pieces, then gifted the park to Price County. Visitors from around the world enjoy the unique sculptures Smith so lovingly created.

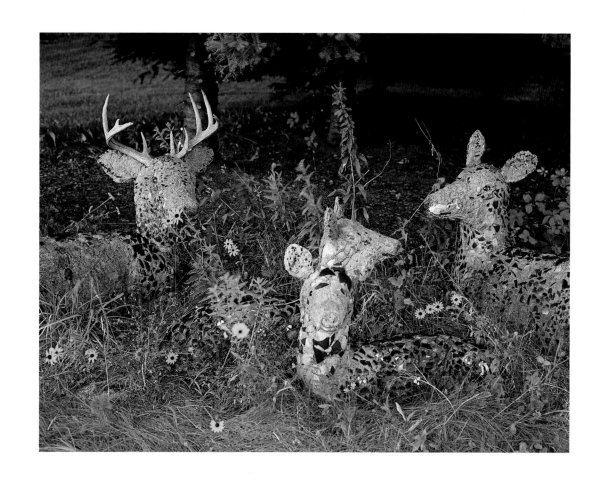

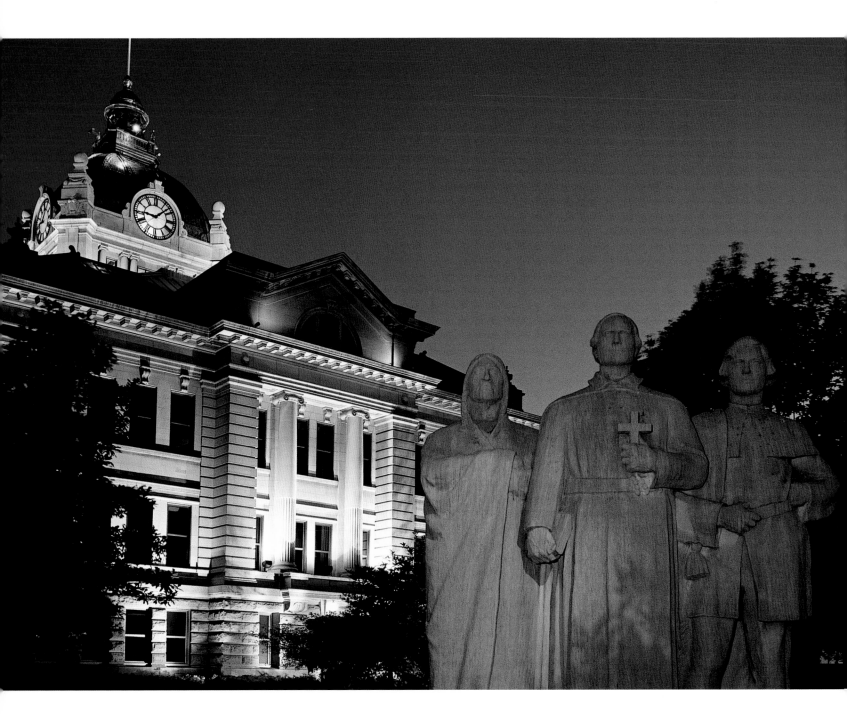

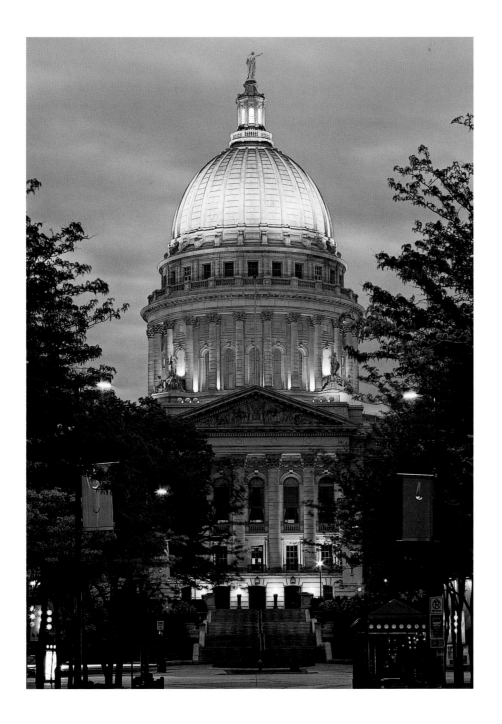

LEFT: When Wisconsin became a state in 1848, Madison, which had been the territorial capital, remained the capital city. The first Madison capitol was built in 1838 and stood for twenty-five years until it was replaced in 1863 by a larger structure. After a devastating fire damaged the second Madison capitol, George B. Post & Sons designed the current capitol, which was built between 1906 and 1917. Rising up between Lakes Monona and Mendota, the building is the only state capitol located on an isthmus.

FACING PAGE: One of the most prominent buildings in downtown Green Bay, the Beaux Arts–style Brown County Courthouse was completed in 1910. The dome is capped with copper and features a bell and clock tower. A sculpture on the grounds entitled *The Spirit of the Northwest,* designed by Sidney Bedore, depicts a Fox Indian, Jesuit missionary Claude Allouez, and French explorer and trader Nicholas Perrot.

RIGHT: The sun drops toward the horizon, casting a path of golden light across the Mississippi River near Alma.

BELOW: A fiery sunrise burns across Lake Michigan, silhouetting pond nets in the waters near Algoma.

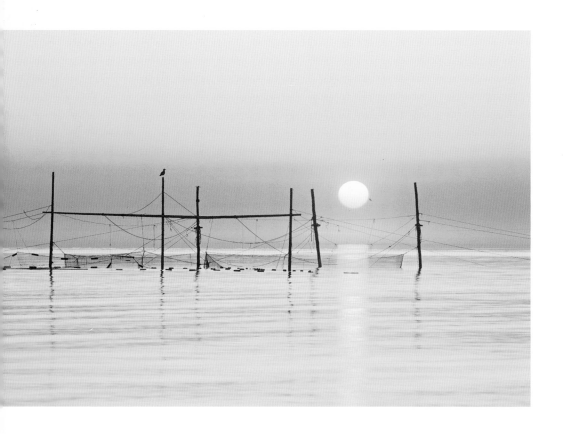

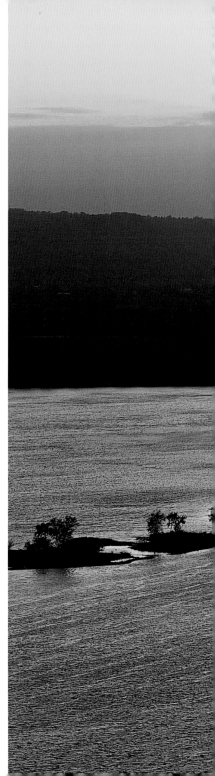

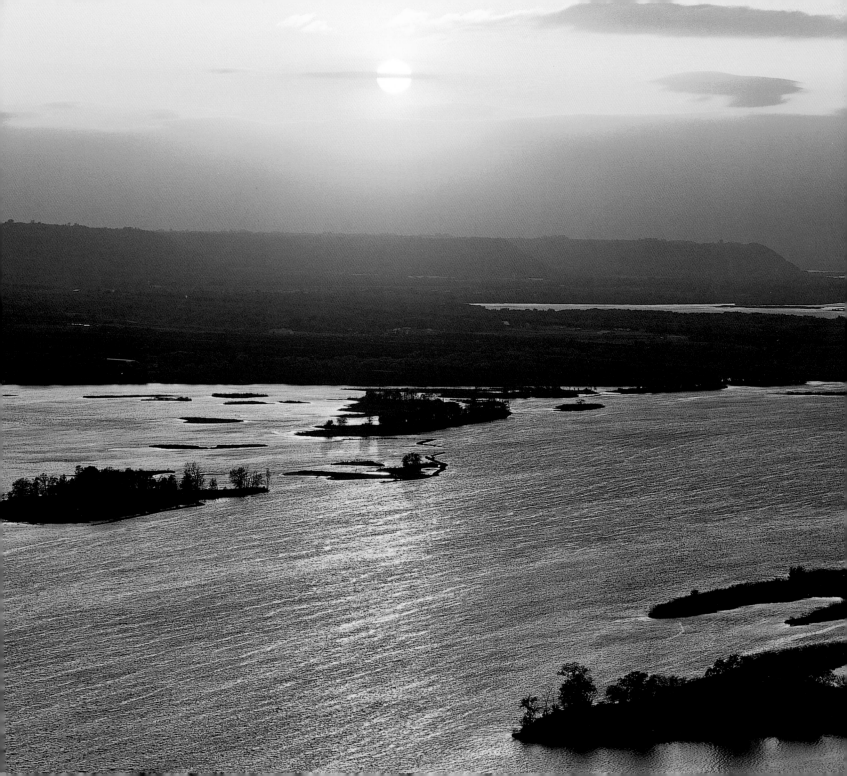

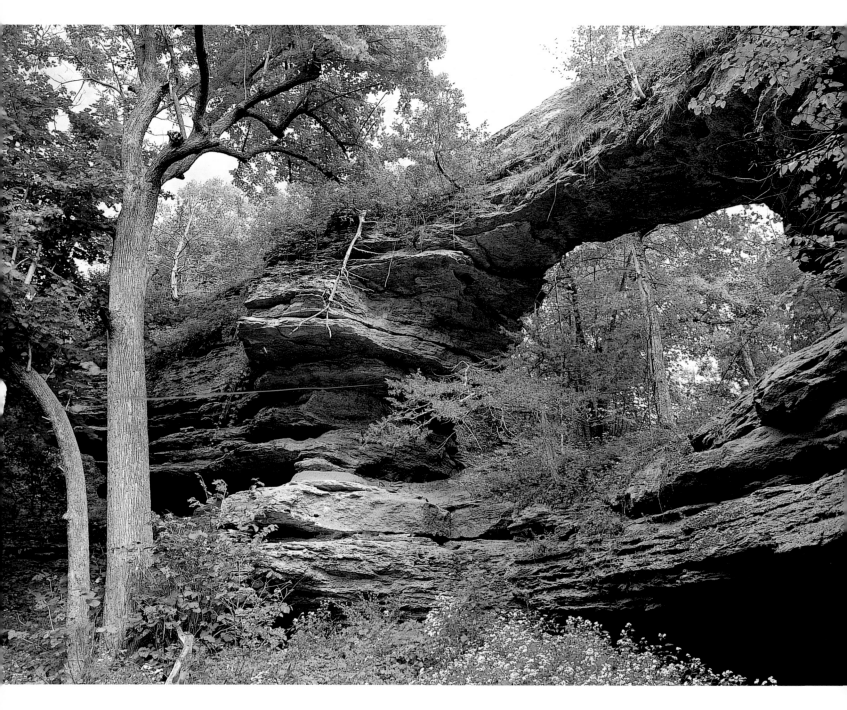

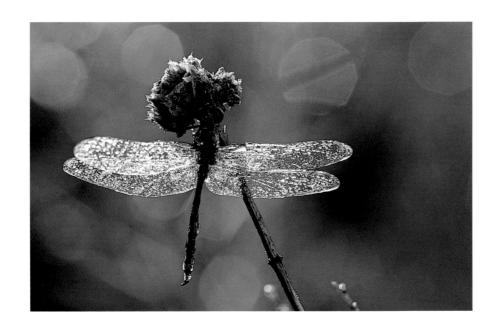

LEFT: A dragonfly alights in a Devil's Lake State Park meadow. The 9,117-acre park is a unit of Ice Age National Scientific Reserve, which was established in 1971 to protect select glacial landforms and landscapes. The reserve is part of the National Park System and consists of nine units administered by the Wisconsin Department of Natural Resources.

LEFT: Natural Bridge State Park was established in 1973 and comprises 530 acres of oak woodlands and prairie and a natural sandstone arch. Carved by wind and water, the opening in the arch is twenty-five feet wide and fifteen feet high, with the top reaching thirty-five feet. At the base of the arch is a rock shelter—sixty feet wide, thirty feet deep—that is believed to have been used by Paleo-Indians approximately 11,000 years ago.

RIGHT: Majestic bluffs tower above Wisconsin's Great River Road as it meanders along the banks of the mighty Mississippi River. This scenic byway, with its stunning views of the river and bluffs, is greatly enhanced by numerous pull-outs, overlooks, parks, and picnic areas.

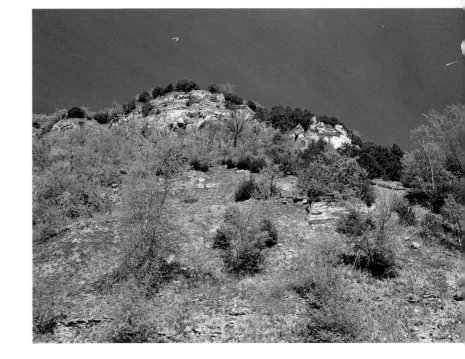

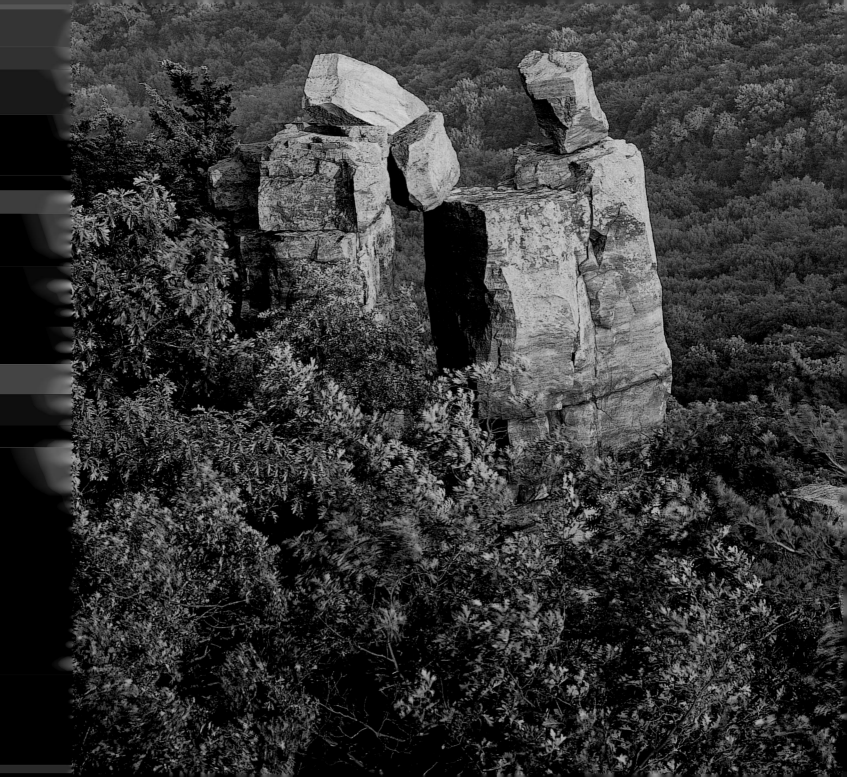

LEFT: Hikers can venture to Devil's Doorway, a rock formation in Devil's Lake State Park.

BELOW: A tree frog makes its way through the woolgrass in Barkhausen Waterfowl Preserve. The 920 acres of forest, meadows, and wetlands are refuge for a wide variety of waterfowl, wildlife, and plant species. More than nine miles of hiking trails wind through the preserve.

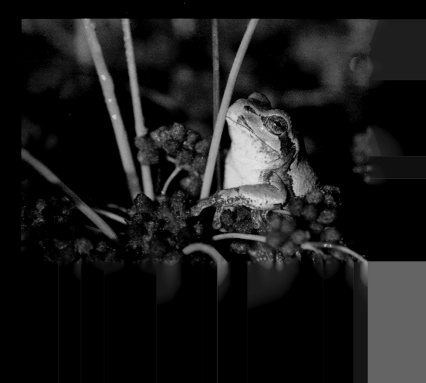

RIGHT: At twilight, a small sailboat plies the waters of Green Bay in Lake Michigan.

BELOW: Built in 1913, the Wisconsin Point Lighthouse (Superior Entry) is positioned at the west entrance to Superior Harbor.

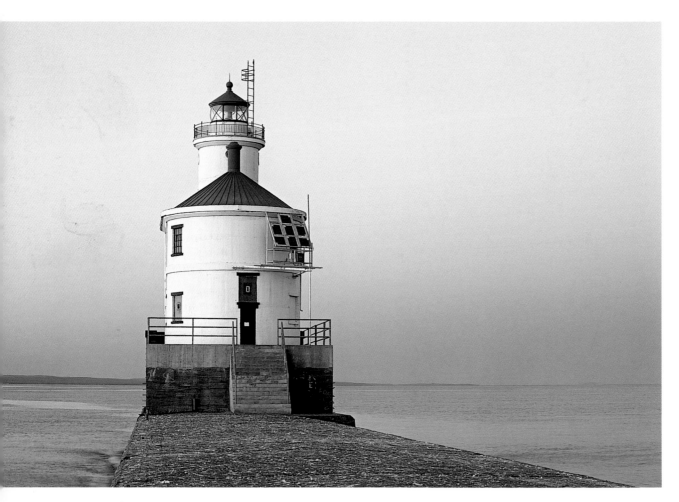

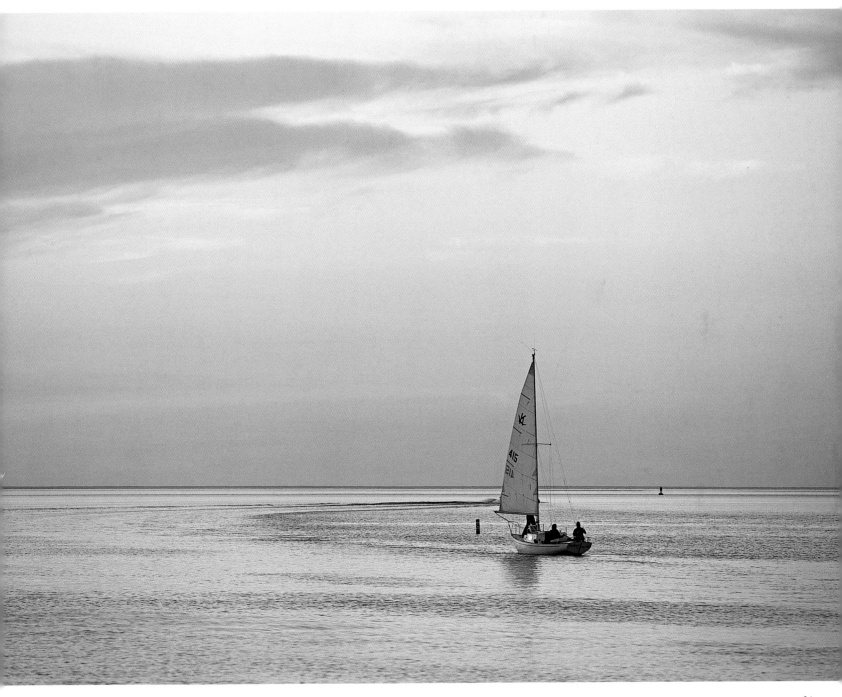

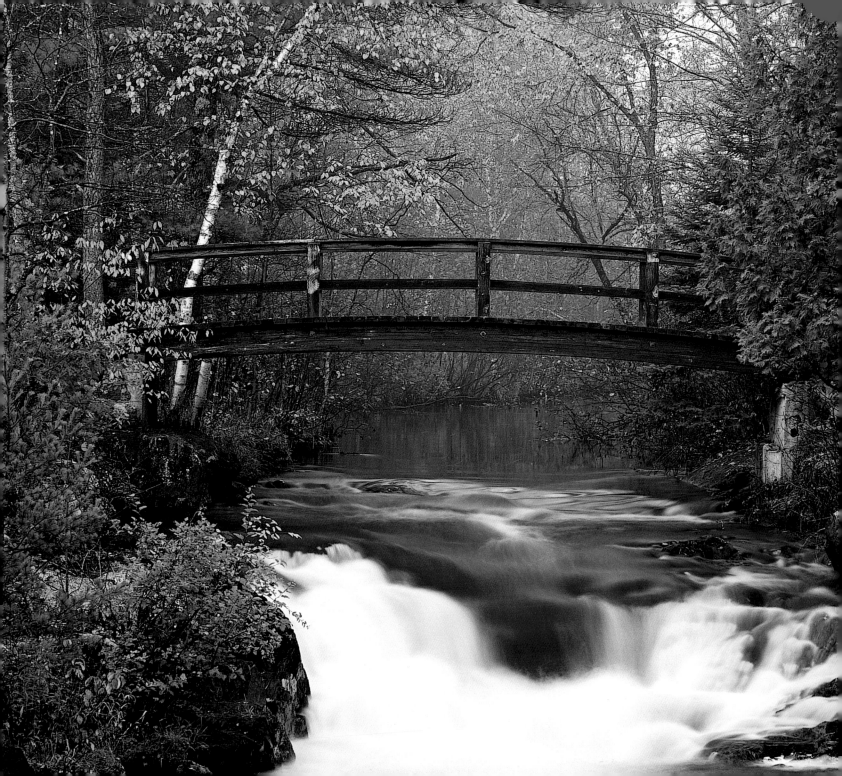

LEFT: Veteran's Bridge gently arcs over the Peshtigo River in 320-acre Veteran's Memorial Park in Marinette County.

BELOW: The Wolf River, considered one of the most scenic and rugged rivers in the Midwest, offers a wild ride to this kayaker.

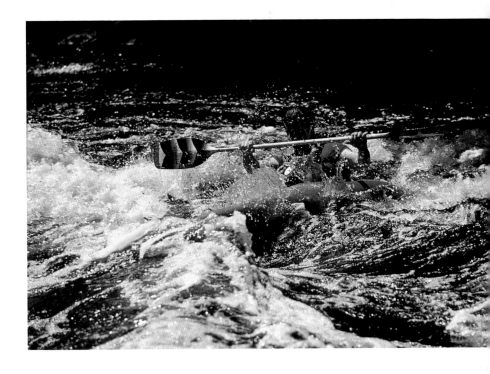

RIGHT: One of the most beautiful lighthouses on Lake Superior, Sand Island Lighthouse was built of sandstone in 1881 on the western end of the Apostle Island chain.

BELOW: Using a chainsaw, a local artisan carved the eighteen-foot-tall lumberjack statue outside Hugo's Log Cabin Restaurant in Ashland from a red pine log from nearby Herbster.

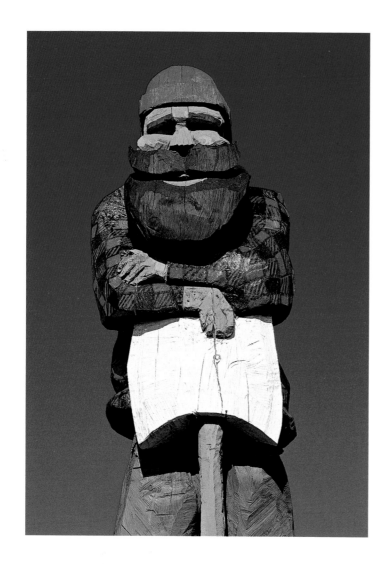

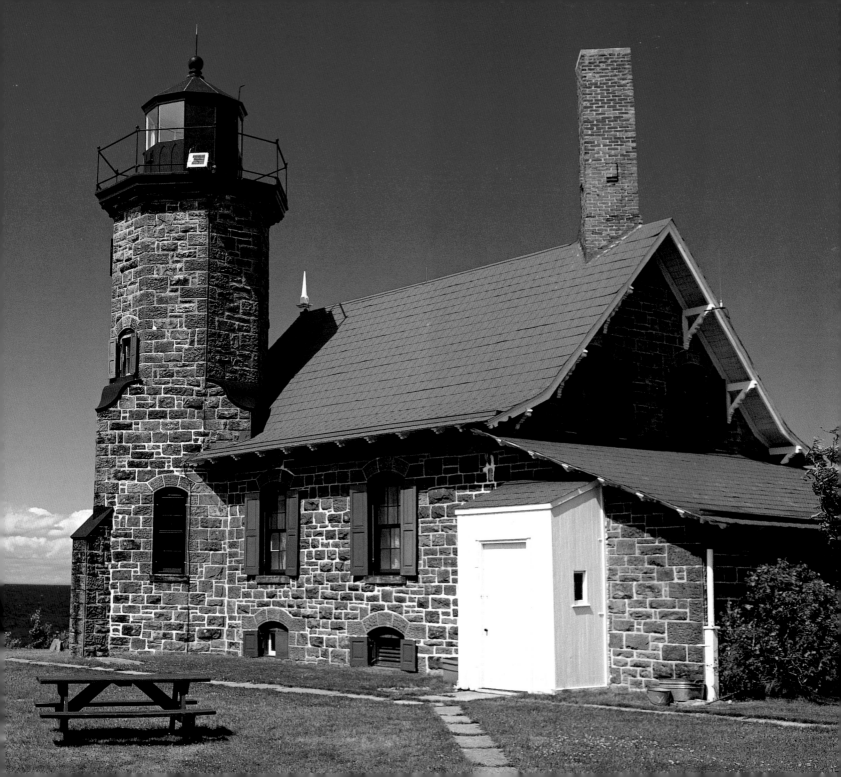

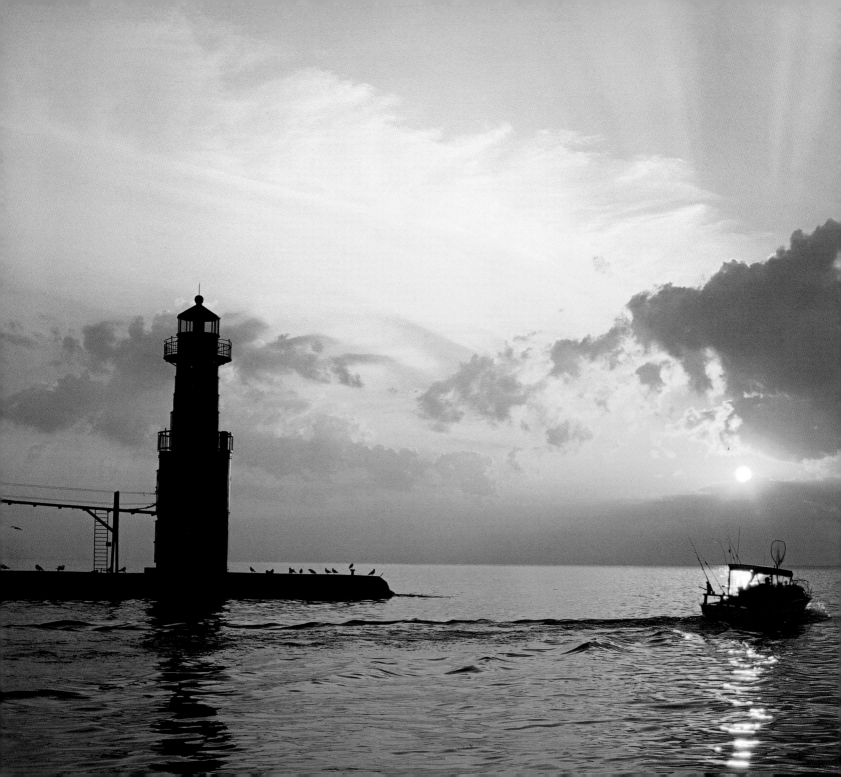

LEFT: Sunlight breaks through the clouds over Lake Michigan as a fishing boat cruises past the Algoma North Pier Light.

BELOW: A Canada goose rises with the sun on a clear morning in Barkhausen Waterfowl Preserve.

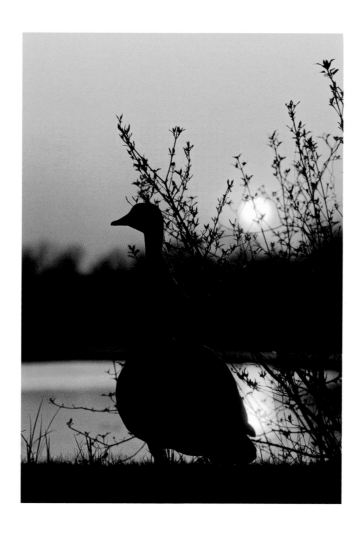

RIGHT: Holsteins graze in a pasture in Marquette County. The official state domestic animal of Wisconsin is the dairy cow. And the official state beverage? Milk.

BELOW: Kids feed the kids at The Farm in Door County, a living history museum of rural life.

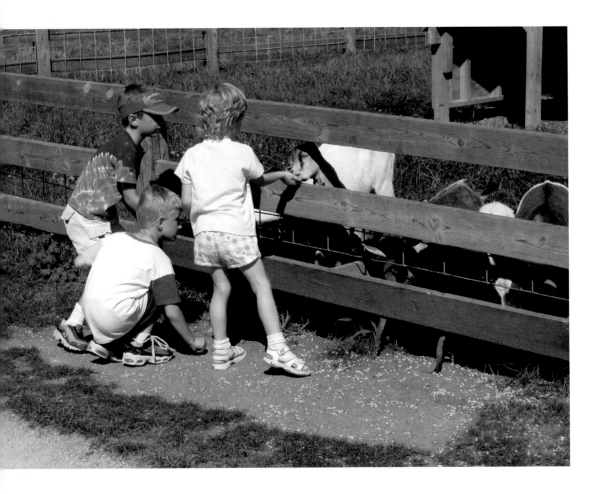

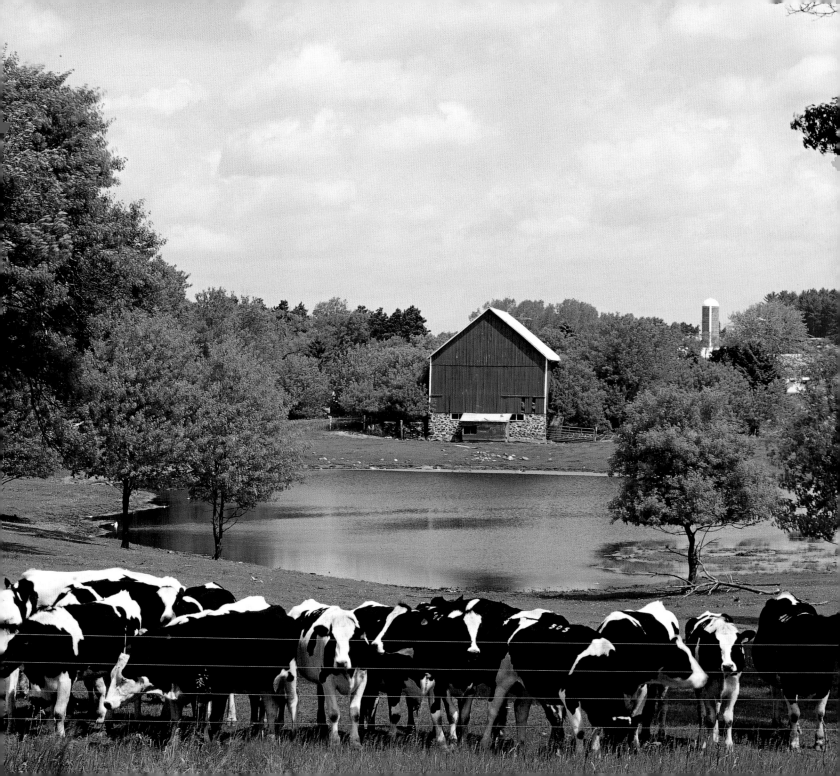

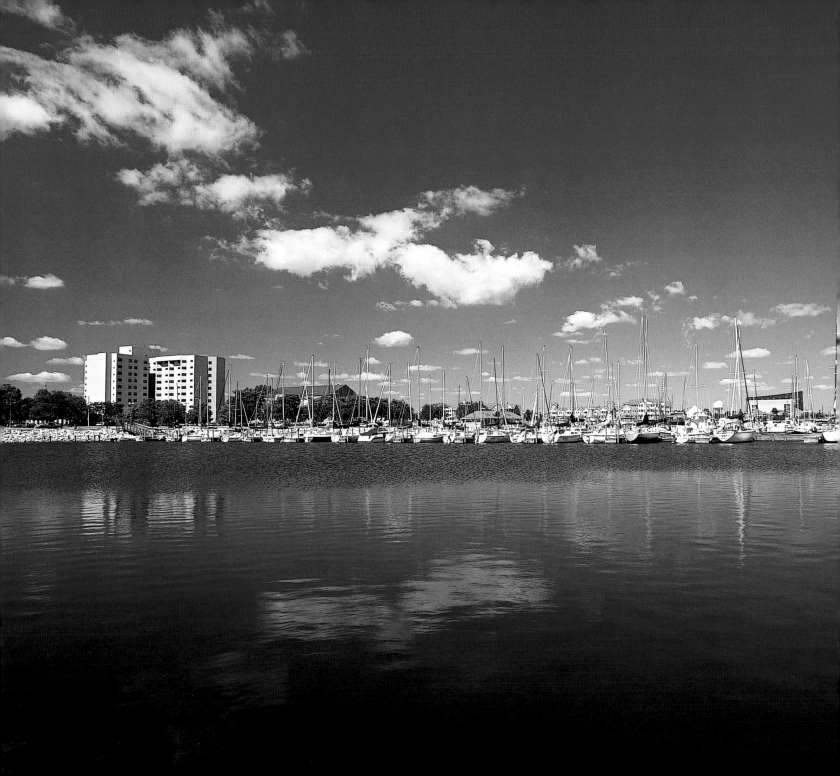

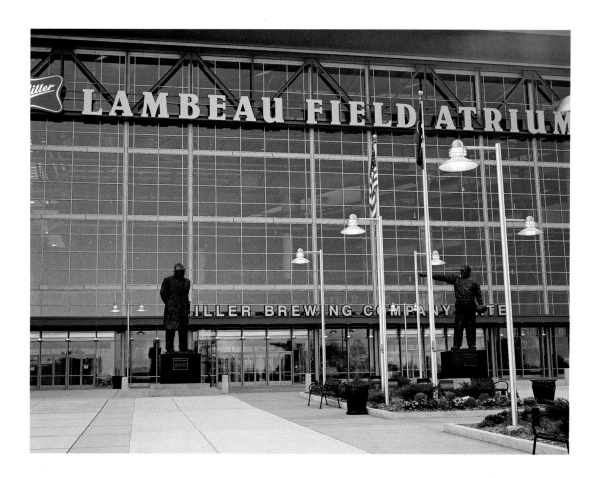

ABOVE: On the northeast side of Lambeau Field, home of the Green Bay Packers, the Lambeau Field Atrium features the Packers Hall of Fame, eateries, and a pro shop. Outside are statues of Vince Lombardi and Curly Lambeau. Lombardi was one of the most successful coaches in the history of football and Packers coach from 1959 to 1968, leading the team to five NFL championships. Curly Lambeau—after whom the stadium is named—was the founder, a player, and the first coach of the Packers.

LEFT: Southport Marina is a public facility in Kenosha's Harbor Park development.

RIGHT: Built in 1850, Hyde's Mill, dam, and millpond are surrounded by lush woodlands and abundant wildlife.

BELOW: The ivory petals of this white trout lily in Abraham's Woods State Natural Area are beginning to open. Abraham's Woods is the home of rare old-growth southern mesic forest and is known for its spectacular display of spring wildflowers.

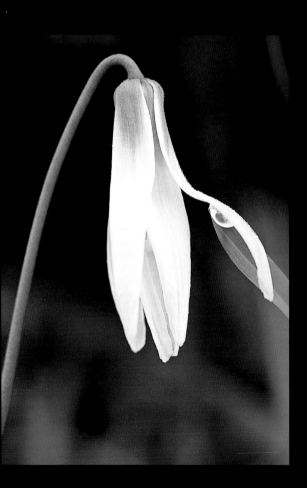

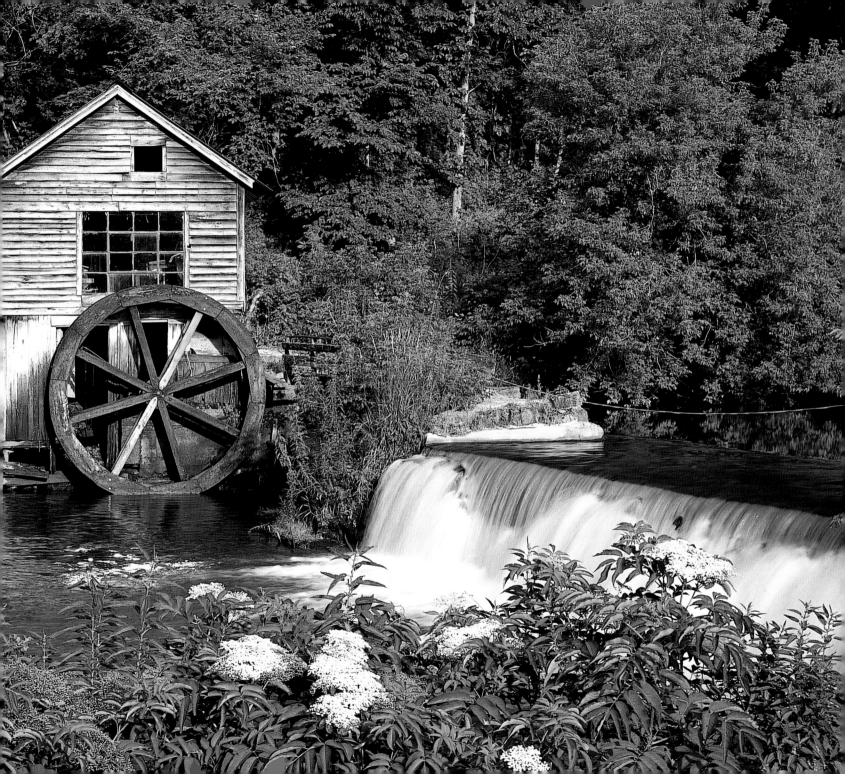

RIGHT: Fall hues grace the shores of Seven Mile Lake in Nicolet National Forest.

FAR RIGHT: A quiet road winds through Kettle Moraine State Forest, located in the Kettle Moraine, which is a series of glacial landforms that extends through southeastern Wisconsin. A kettle occurs when a glacier retreats, leaving behind large chunks of ice that are covered by sediment. When the ice melts, a hole is left behind.

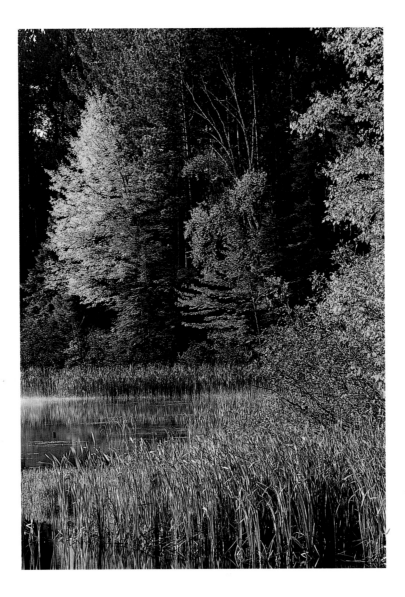

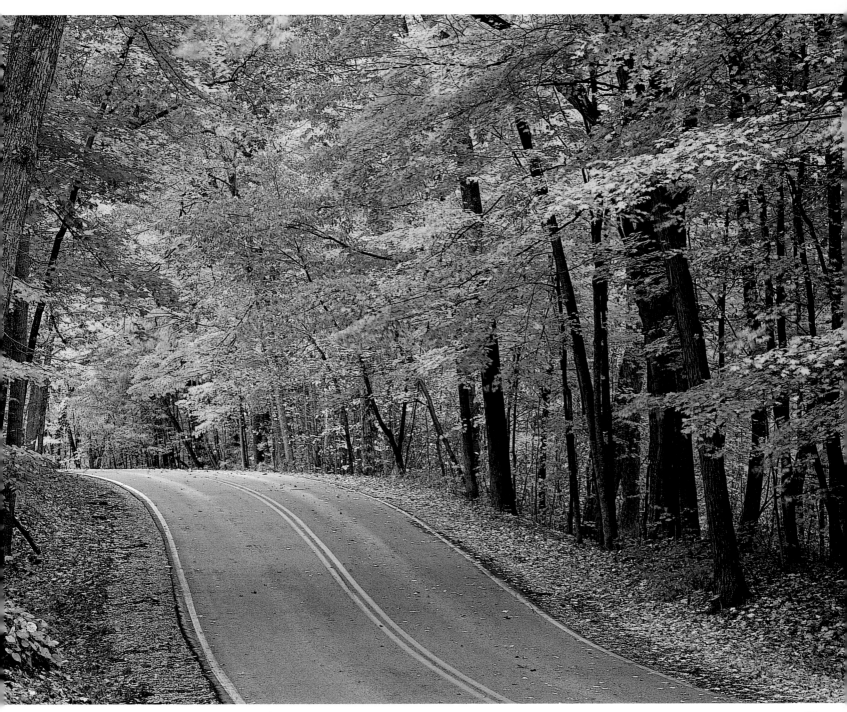

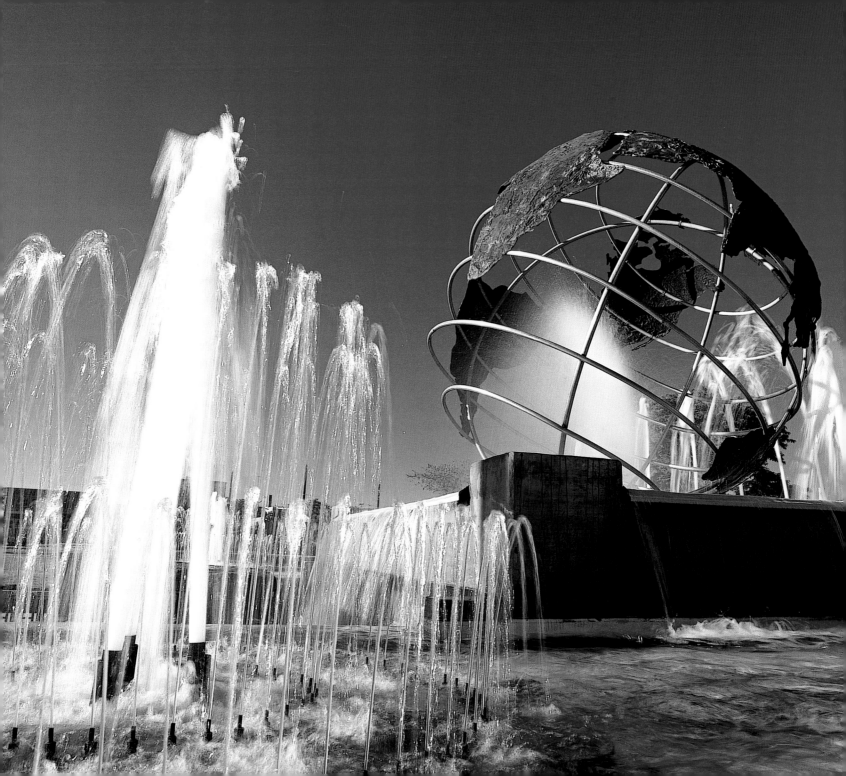

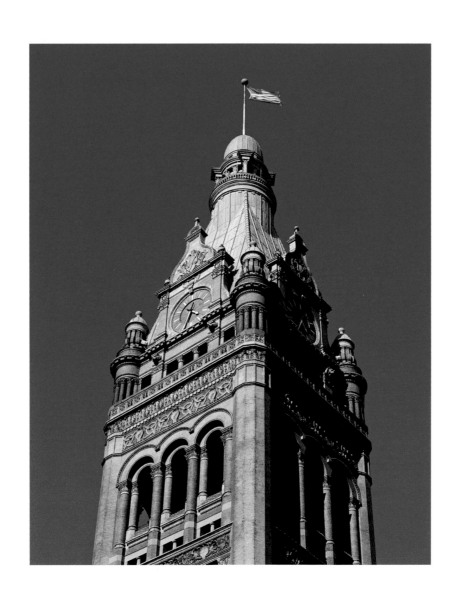

LEFT: Completed in 1895, the Milwaukee City Hall building was designed in the Flemish Renaissance style and, at the time, was one of the tallest buildings in the world.

FAR LEFT: The Veteran's Memorial Park Fountain in Kenosha features items from historic battlegrounds, including an eight-ton boulder from Okinawa and sand from Omaha and Utah beaches in Normandy. At the center is a stainless-steel globe with continents made of cast bronze.

RIGHT: A young dancer competes at the Indian Summer Festival in Milwaukee. The annual event celebrates both traditional and contemporary American Indian culture.

BELOW: American Indian vendors at the Indian Summer Festival offer a variety of crafts, including jewelry, music, pottery, and colorful blankets like these.

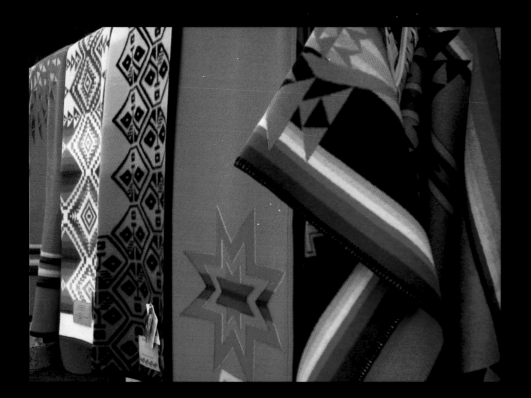

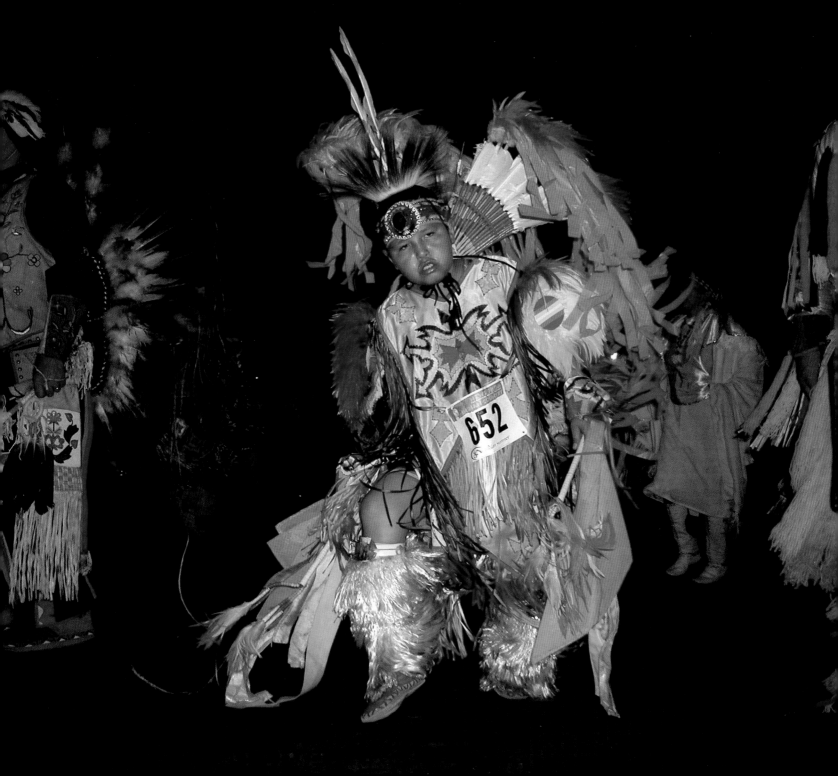

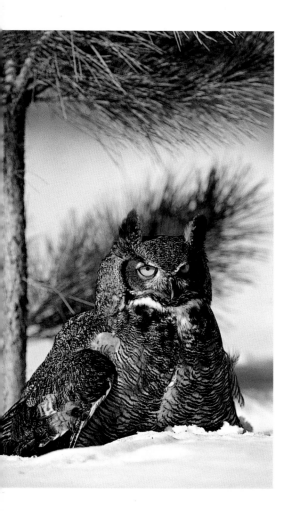

LEFT: A great horned owl searches for prey in the snow. These owls are distinguished by their prominent hornlike ear tufts. PHOTO BY R. J. AND LINDA MILLER

RIGHT: Waves crash and freeze on the pier leading to the Sheboygan Breakwater Light. The lighthouse was constructed of cast iron and brought by boat to Sheboygan in 1915. A crane lowered the light to a foundation on the pier, and an octagonal lantern room was placed on top. The lantern room and gallery were removed and replaced with a modern plastic lens, which casts light that is visible from nine miles away.

BELOW: A red fox wanders out onto a chunk of ice jutting into a stream. About three feet in length, red foxes only weigh nine to twelve pounds when full grown. PHOTO BY R. J. AND LINDA MILLER

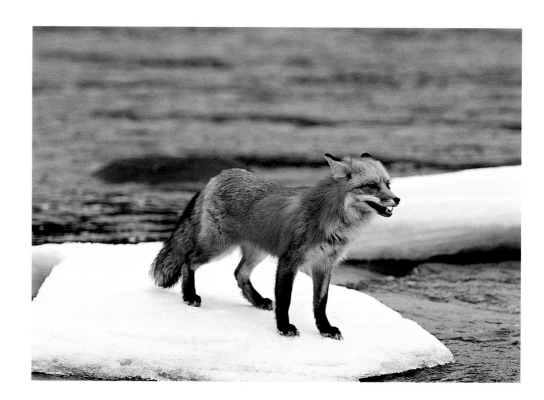

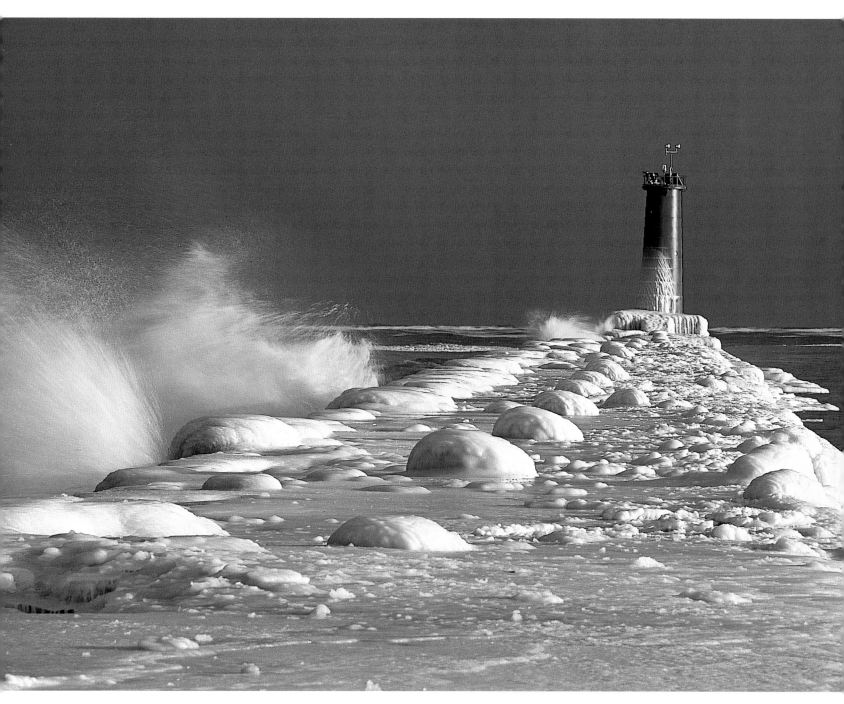

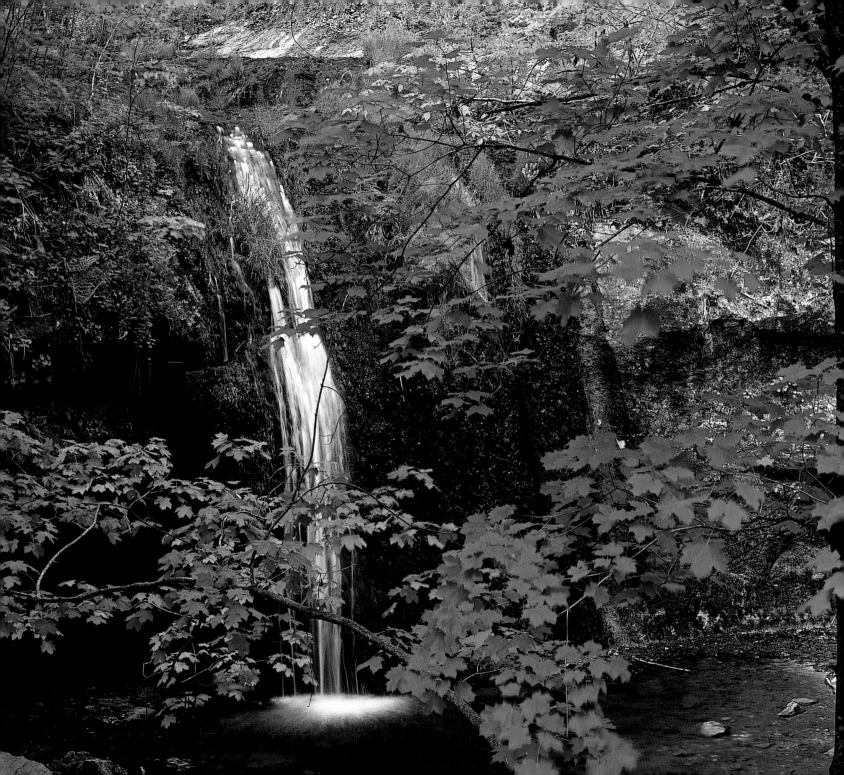

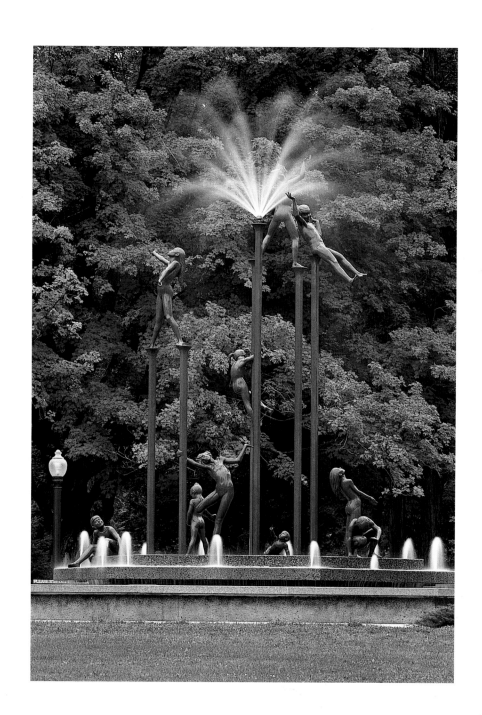

LEFT: This unique sculpture entitled *Playing in the Rain* by Dallas J. Anderson graces Kimberley Point Park in Neenah.

FAR LEFT: In verdant Governor Dodge State Park, the Stephen's Falls hiking trail leads visitors to the waterfall of the same name.

RIGHT: Mimicking a forest canopy, wooden slats shade ginseng growing on a farm in Marathon County. Wisconsin ginseng is considered among the purest, highest quality ginseng in the world. The white root is believed to relieve stress, improve stamina, and increase resistance to common illnesses such as colds.

FAR RIGHT: Wisconsin's mineral-rich soil makes it ideal for growing many kinds of crops.

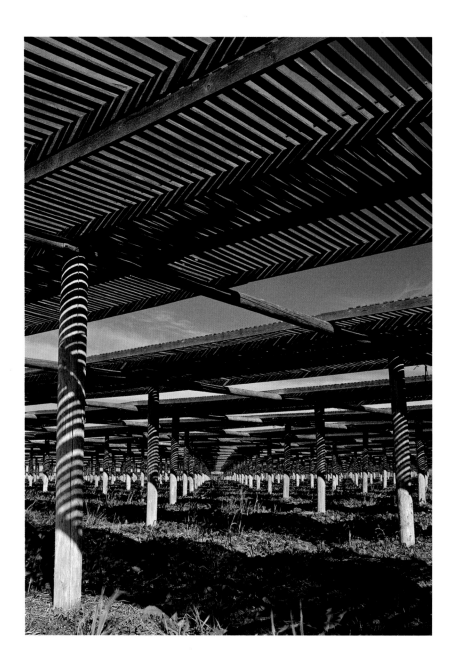

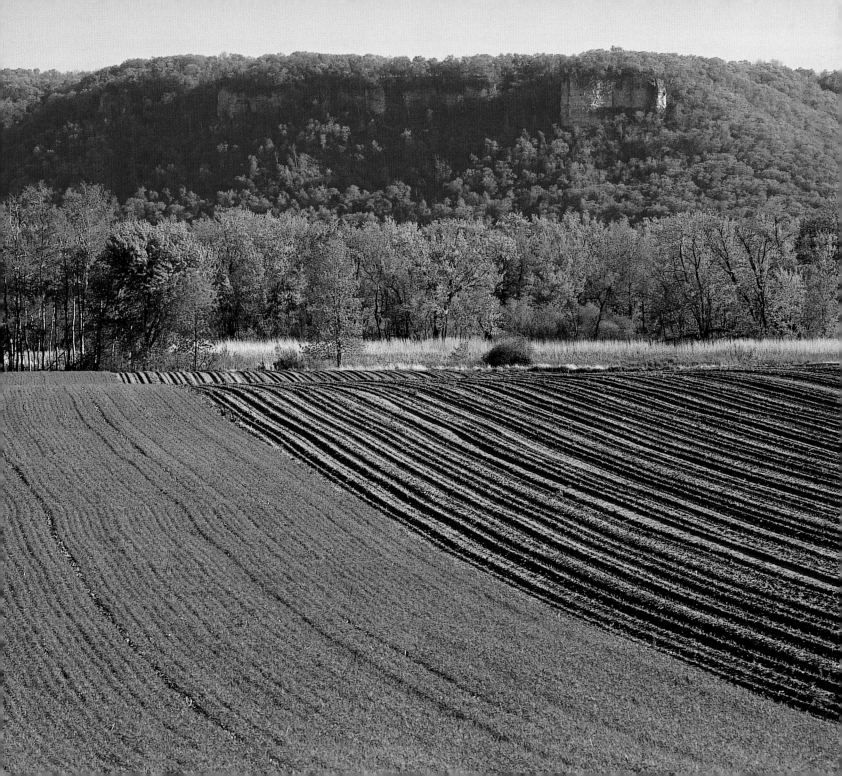

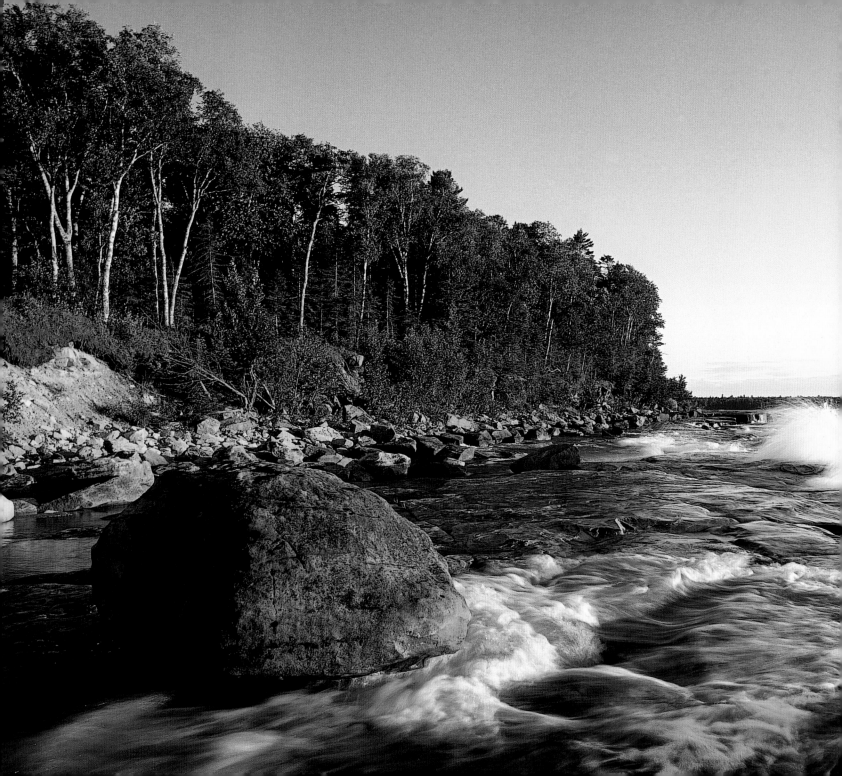

LEFT: Lake Superior's waves crash against the shore at Sand Island, part of the Apostle Islands National Lakeshore. Twenty-two islands off the Bayfield Peninsula and a twelve-mile strip of land on Wisconsin's north coast make up the Apostle Islands National Lakeshore.

BELOW: Amid the hiking trails at High Cliff State Park are the remnants of the tall stone ovens from a lime kiln that operated there from 1895 to 1956. The lime extracted in the kiln was used in plaster and cement and mixed with soil to reduce acidity. The park is named after a particular limestone cliff on the Niagara Escarpment.

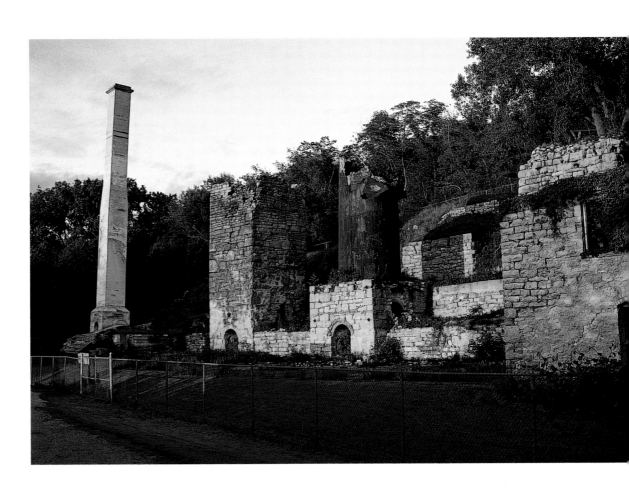

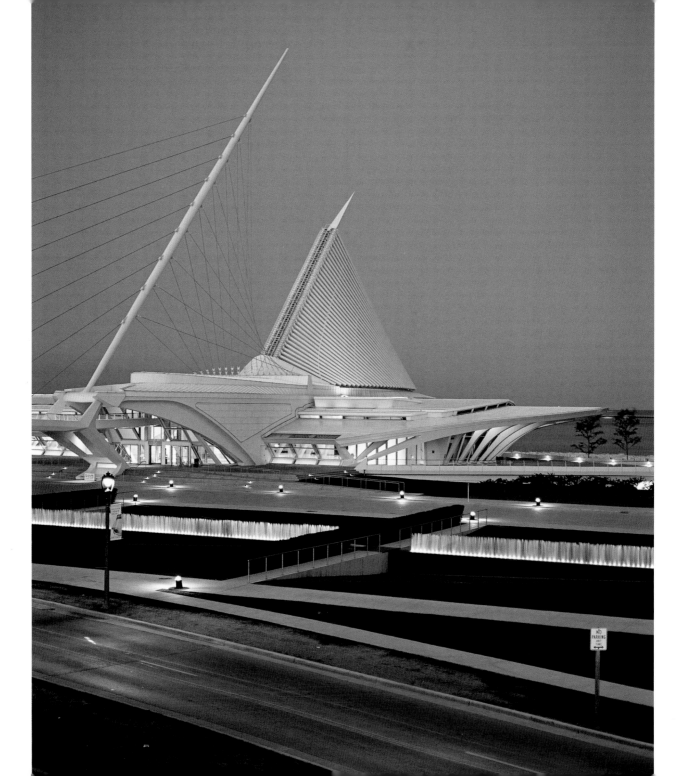

FACING PAGE: This unique structure is home of The Milwaukee Museum of Art. The moveable, winglike sunscreen that tops the museum's glass-enclosed reception hall is called the Burke Brise Soleil and is unprecedented in American architecture.

BELOW: The World War II fleet submarine USS *Cobia* is docked along the Manitowoc River at the Wisconsin Maritime Museum. Twenty-eight subs similar to this one were built in Manitowoc during World War II. Launched in November 1943, the *Cobia* had a colorful service record, and in 1986 it was incorporated as a part of the Manitowoc Maritime Museum. It was declared a National Historic Landmark and placed on the National Register of Historic Places.

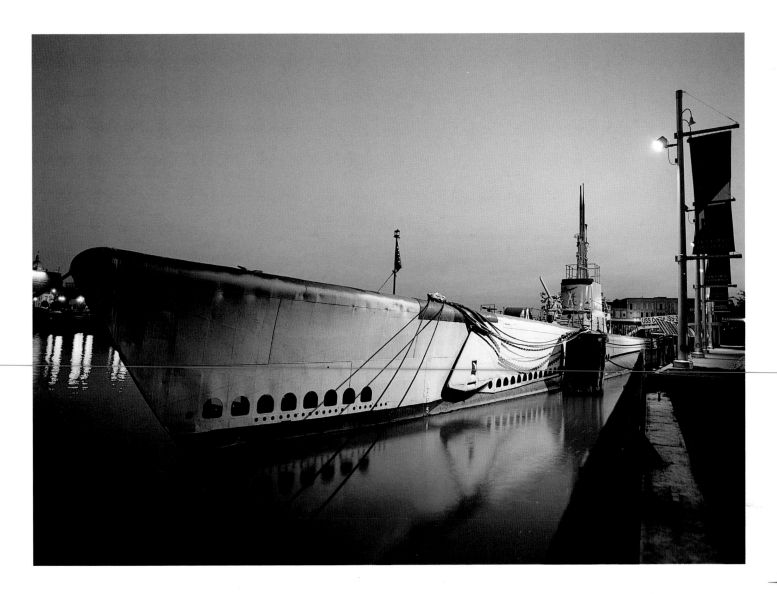

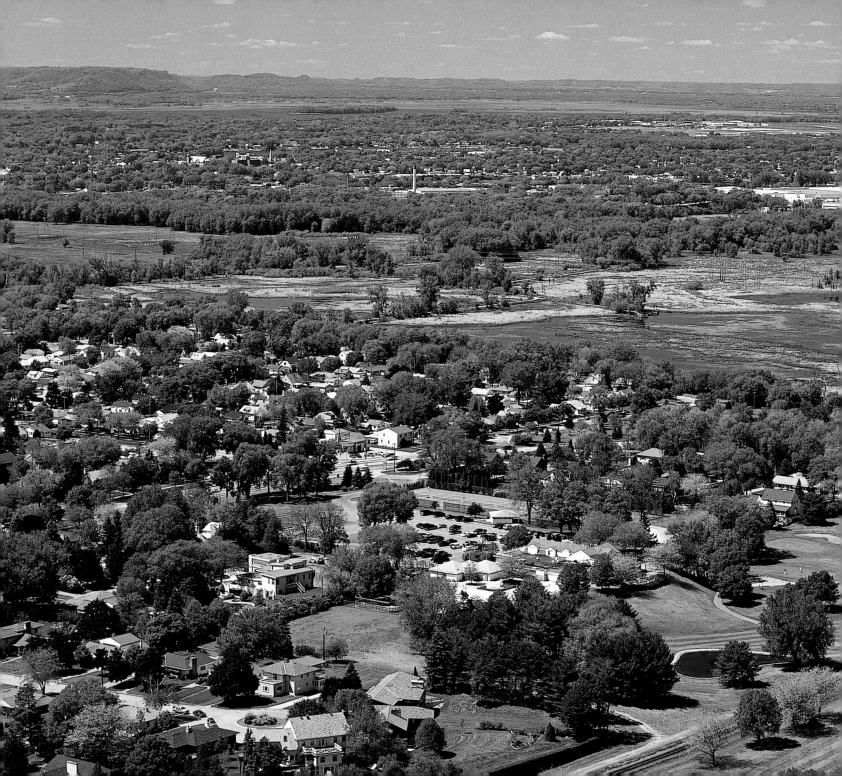

LEFT: The overlook on Grandad Bluff offers sweeping views of the communities of La Crosse and North La Crosse. When the bluff was threatened with quarry development in 1909, the prominent Hixon family bought the land and held it in trust until 1912, when it was donated as a park to the city of La Crosse.

BELOW: The sunfish-themed signage telling visitors they've arrived in Onalaska is fitting; the small city is popular with anglers and overlooks the Mississippi River Valley. The valley is a broad expanse of water—including the Mississippi River, Lake Onalaska, and the Black River—that is dotted with small islands.

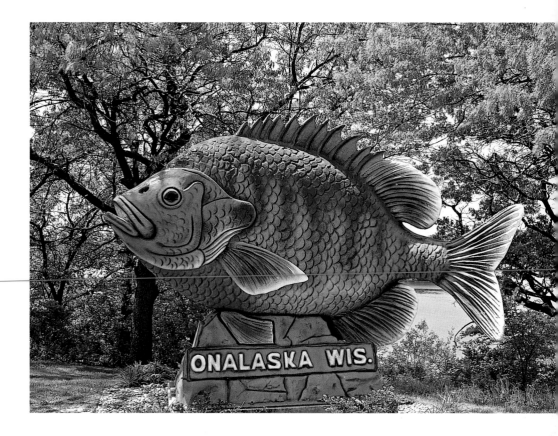

FACING PAGE: Gilded circus wagons are displayed at the Circus World Museum in Baraboo. The museum is located at the site of the original Ringling Brothers Circus winter quarters and is a National Historic Landmark. The museum offers exhibits and activities for families and is also home of the Robert L. Parkinson Library and Research Center, the world's foremost research facility of circus history.

BELOW: Using found objects, outsider artist Herman Rusch created a garden of outdoor sculpture near Fountain City called Prairie Moon Sculpture Garden and Museum. Born in 1885, Rusch didn't begin his creations until 1952; Rusch died in 1985, days after his one-hundredth birthday.

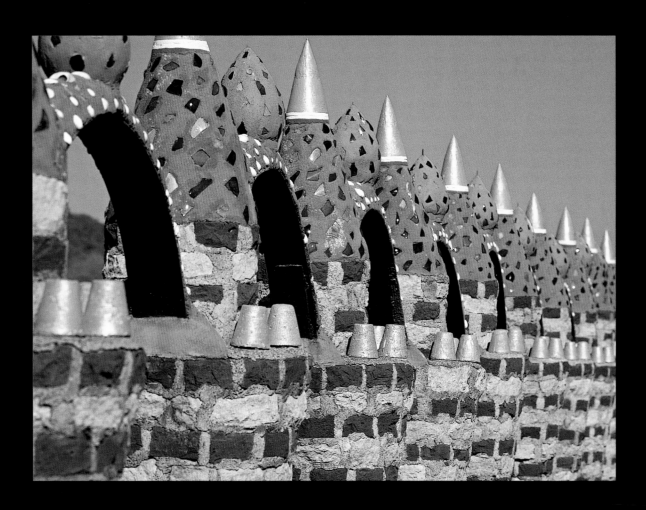

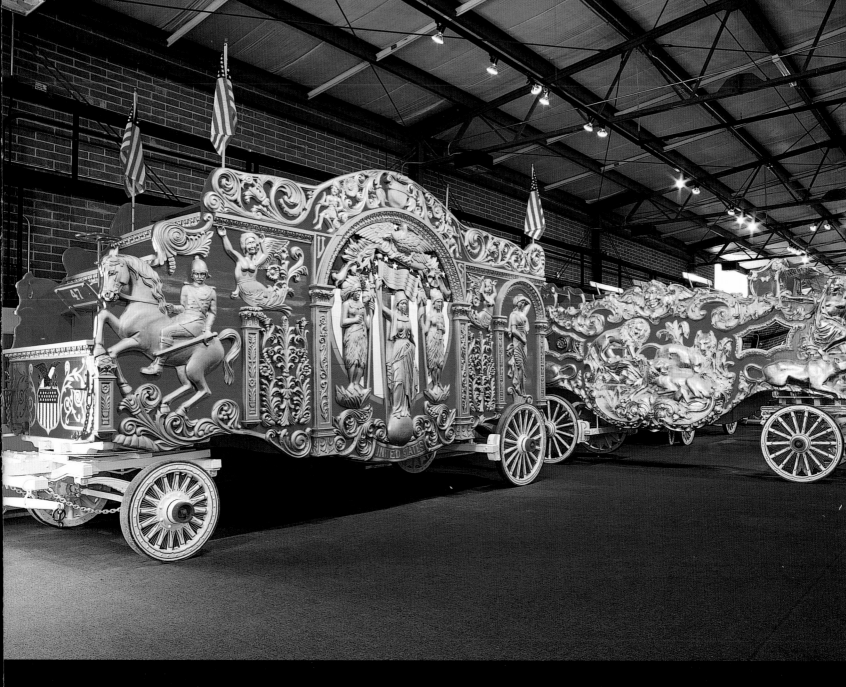

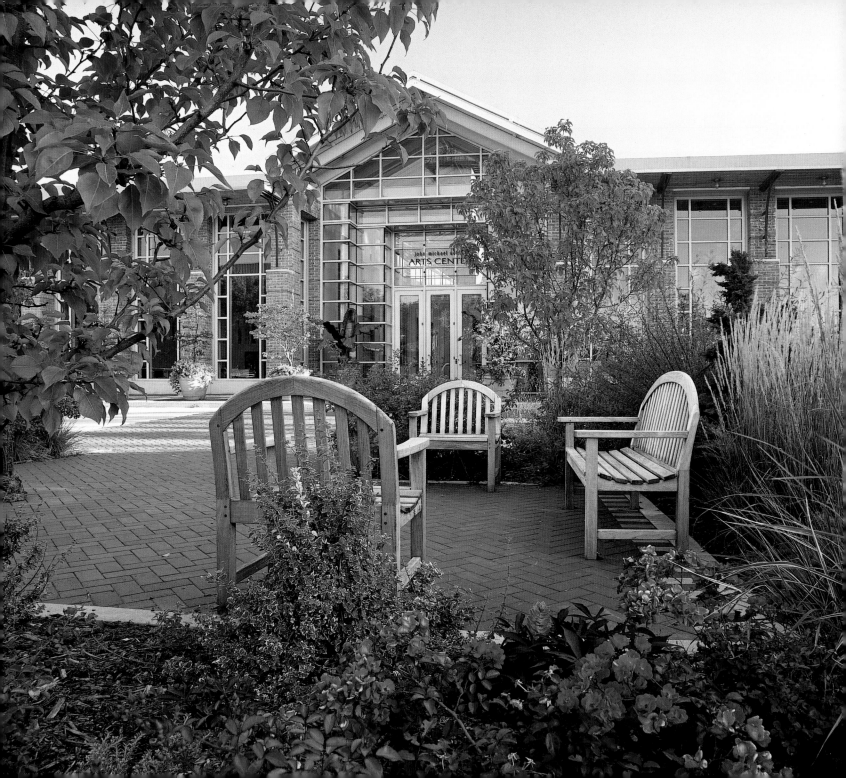

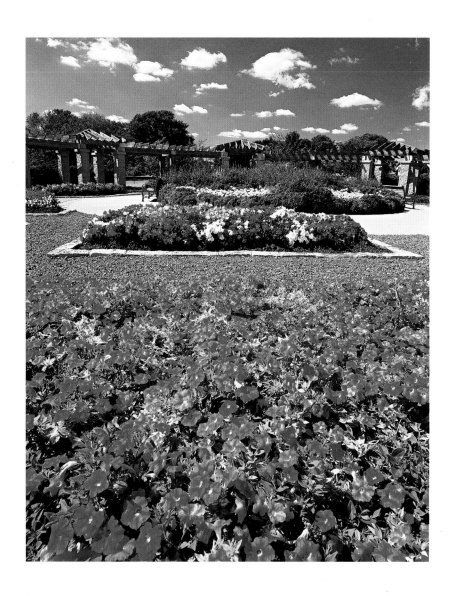

LEFT: Petunias bloom in fifteen-acre Wolfenbuttel Park, which features flower gardens, a gazebo, the Kenosha Youth Memorial, and bike paths.

FAR LEFT: Founded in the late 1960s, the John Michael Kohler Arts Center makes its home in downtown Sheboygan. The center explores the innovations of contemporary American art.

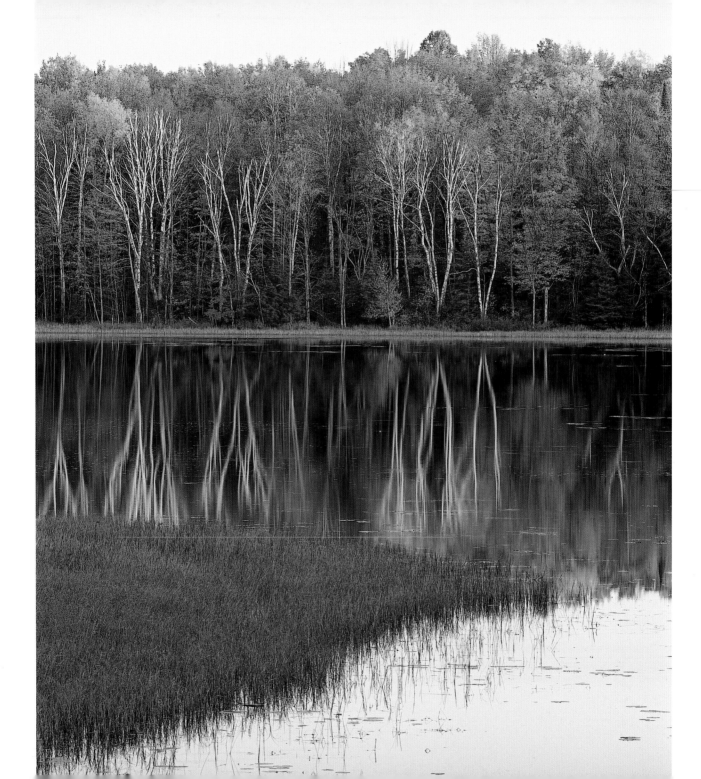

FACING PAGE: A tranquil autumn scene reflects in the glassy waters of Kazmier Lake in Nicolet National Forest.

BELOW: As morning sun warms the air, steam rises off the cool waters of Chain Lake, which occupies eighty-one acres in Oconto County.

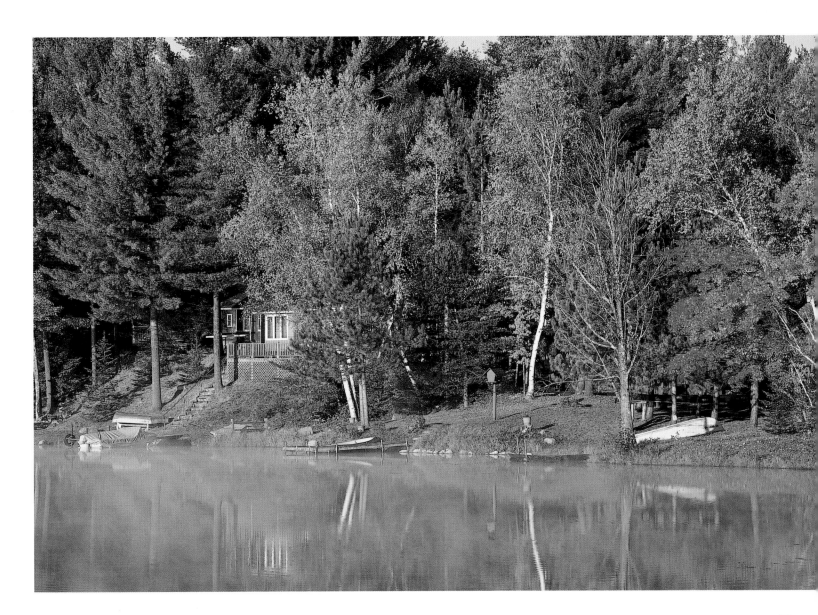

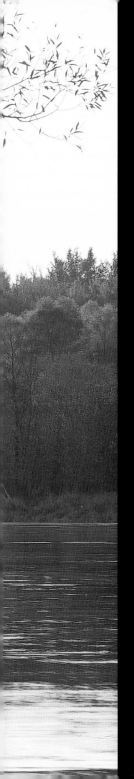

LEFT: The St. Croix River State Forest was established in 1970 and was re-designated the Governor Knowles State Forest in 1981 to recognize former Governor Warren P. Knowles for his conservation work. The forest protects the St. Croix National Scenic Riverway.

BELOW: A white-tailed deer fawn beds down in a field of dandelions. The white-tailed deer is the official state animal of Wisconsin. PHOTO BY R. J. AND LINDA MILLER

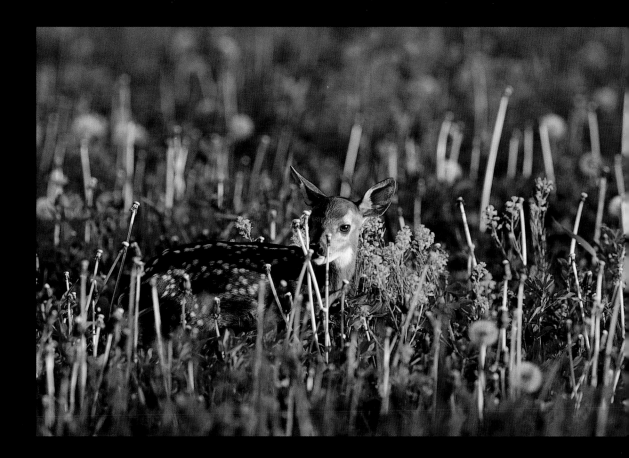

RIGHT: Racine's 108-foot-tall Wind Point Lighthouse, completed in 1880, casts a signal light over the icy waters of Lake Michigan.

BELOW: Snowmobilers race across the frozen surface of Lake Minocqua in northern Wisconsin. PHOTO BY R. J. AND LINDA MILLER

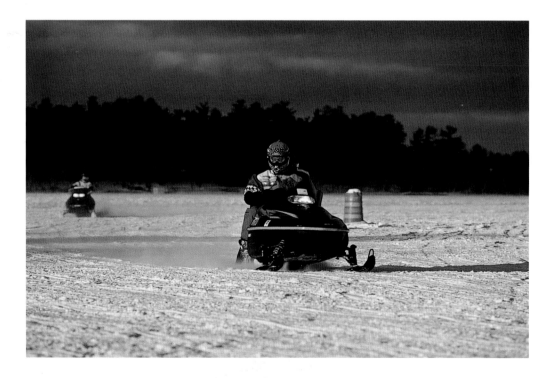

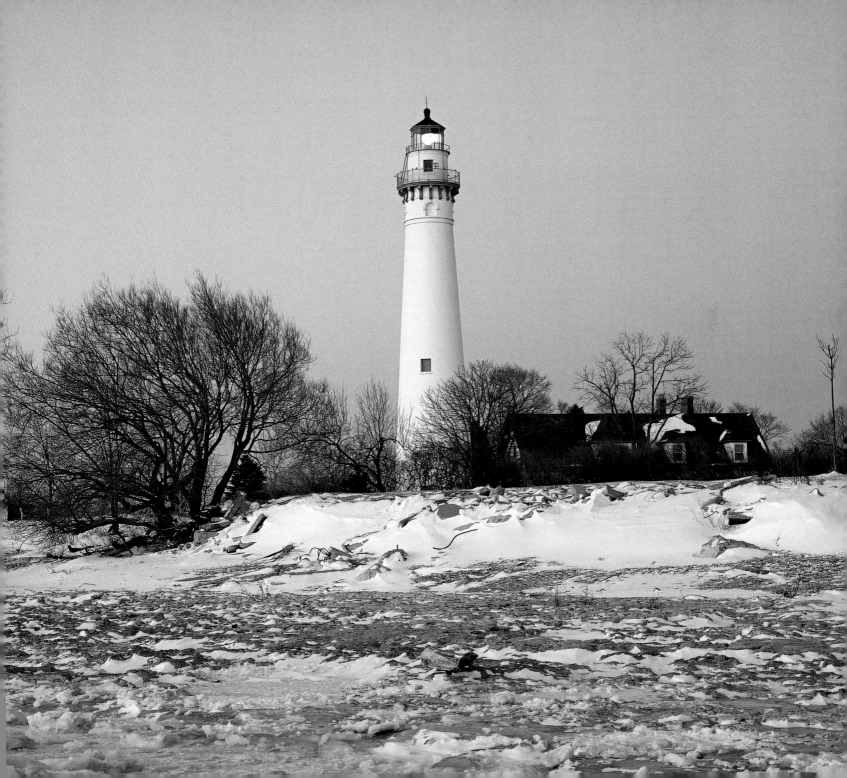

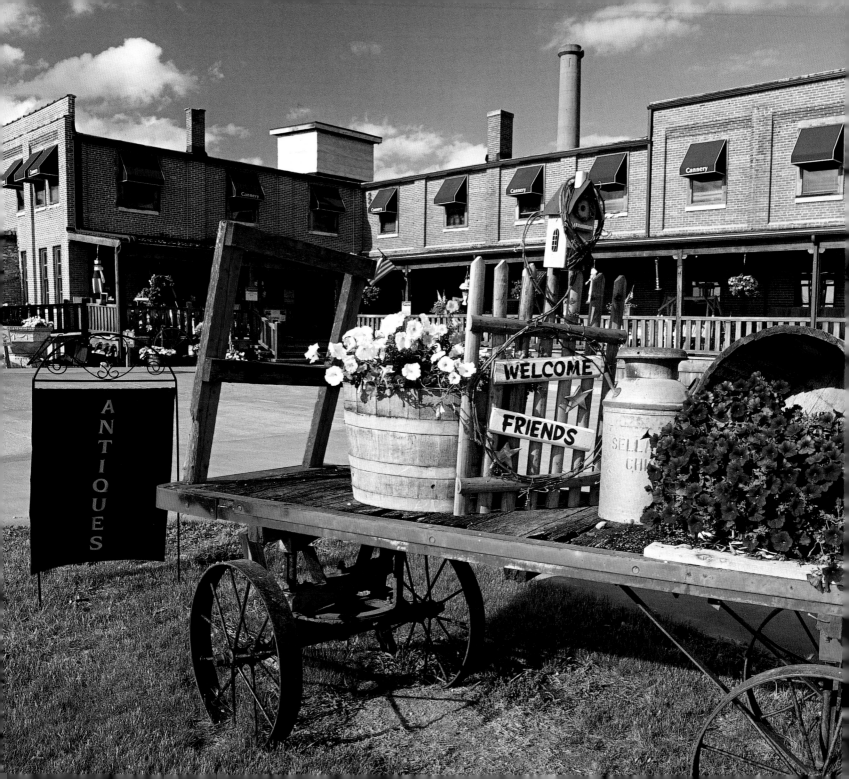

LEFT: Housed in the former Prairie du Chien City Canning Company, The Cannery Antiques offers visitors a chance to stroll past relics of bygone days.

BELOW: Two Amish girls take a walk near Bonduel. Wisconsin has a large Amish population, the first arriving in the 1920s.
PHOTO BY R. J. AND LINDA MILLER

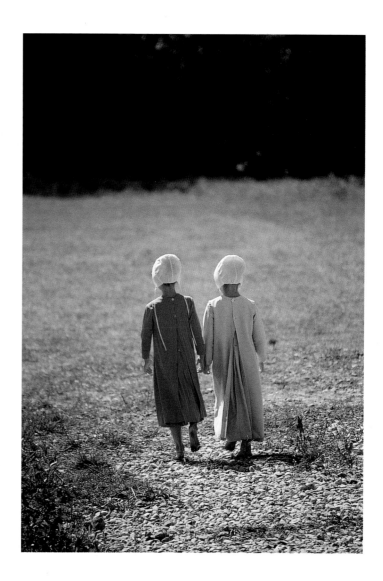

RIGHT: Smiling softly, a ten-foot-tall snowman stands proud in front of an old red barn in Marshfield.

FAR RIGHT: Located in Willard, the Christine Center is a non-denominational retreat center embracing the diversity of all spiritual traditions.

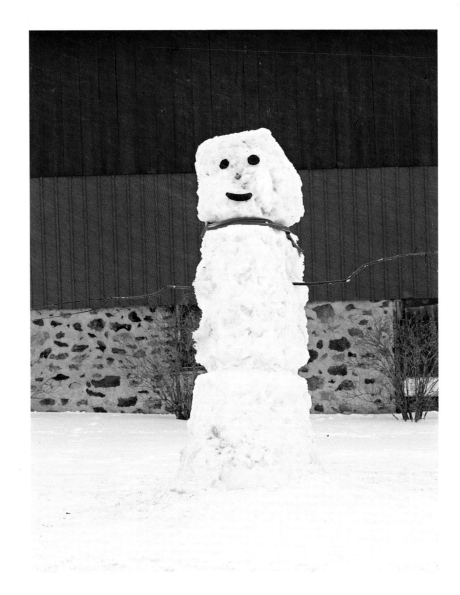

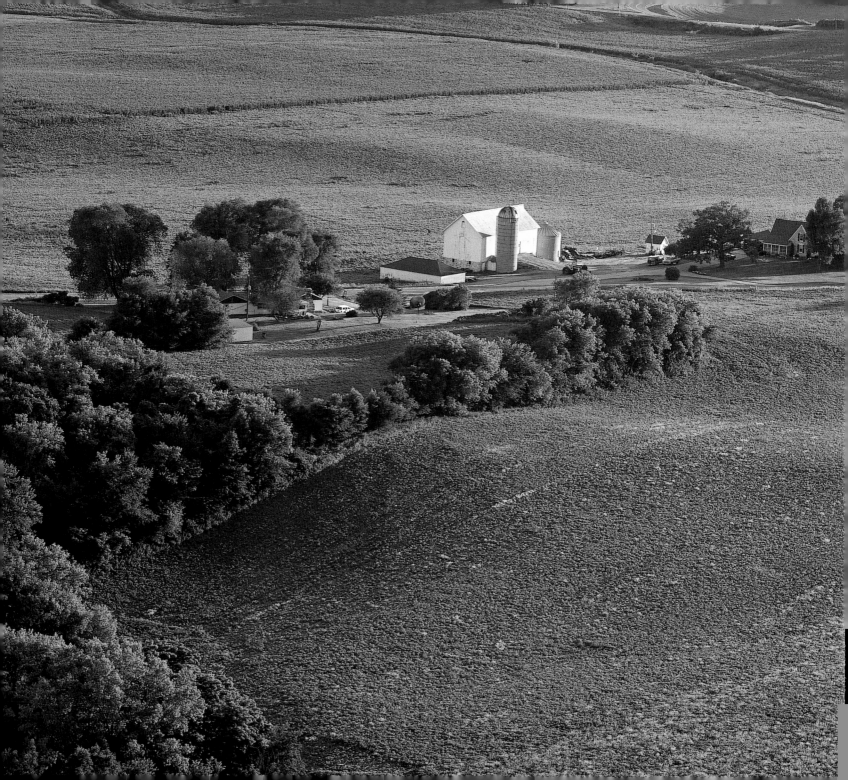

LEFT: This charming pastoral scene was photographed from Gibraltar Rock in Columbia County.

BELOW: Bright-white cherry blossoms, these near Egg Harbor in Door County, mean spring has arrived.

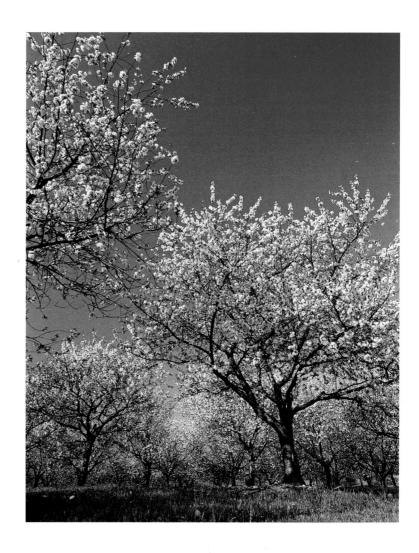

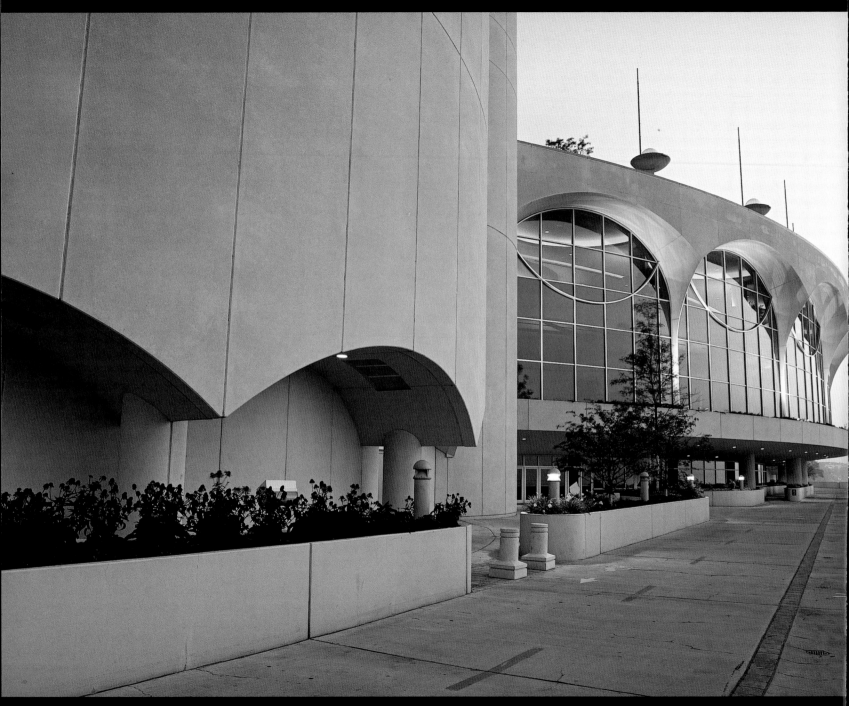

LEFT: Sunrise stains lavender the Monona Terrace Community and Convention Center. The building was first designed by Wisconsin-native and renowned architect Frank Lloyd Wright from 1938 to 1959 as a building for cultural, governmental, and recreational events. The exterior follows Wright's design plans, but the interior was redesigned by Wright-apprentice Tony Puttnam to create exhibition and meeting space.

BELOW: A pleasing mix of wildflowers on the Greene Prairie lies beneath a pastel sky. Prairie-expert Henry Greene replanted native species in this fifty-acre preserve in the 1940s and 1950s. The prairie continues to thrive as part of the University of Wisconsin Arboretum.

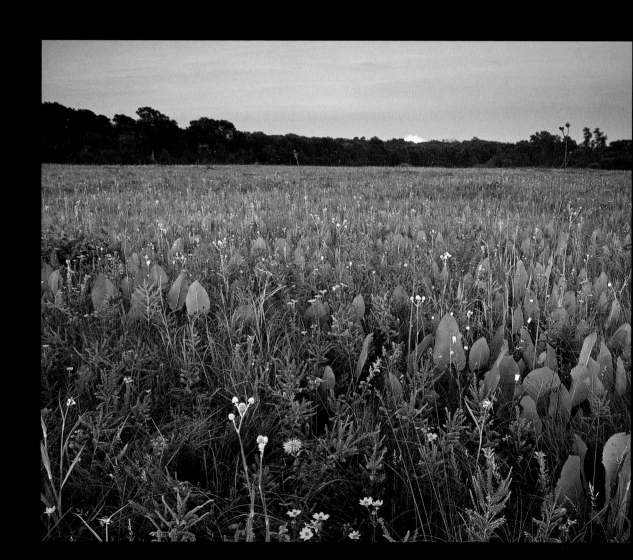

RIGHT: A tugboat pushes several river barges up the Mississippi River near Trempealeau.

FAR RIGHT: From the Buena Vista Lookout at Alma, visitors can view Lock and Dam No. 4 on the Mississippi River. Bald eagles nest below the lock and dam—the best viewing is November through April.

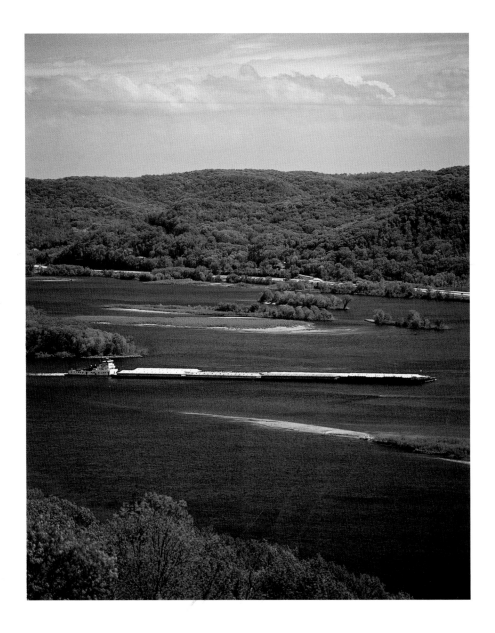

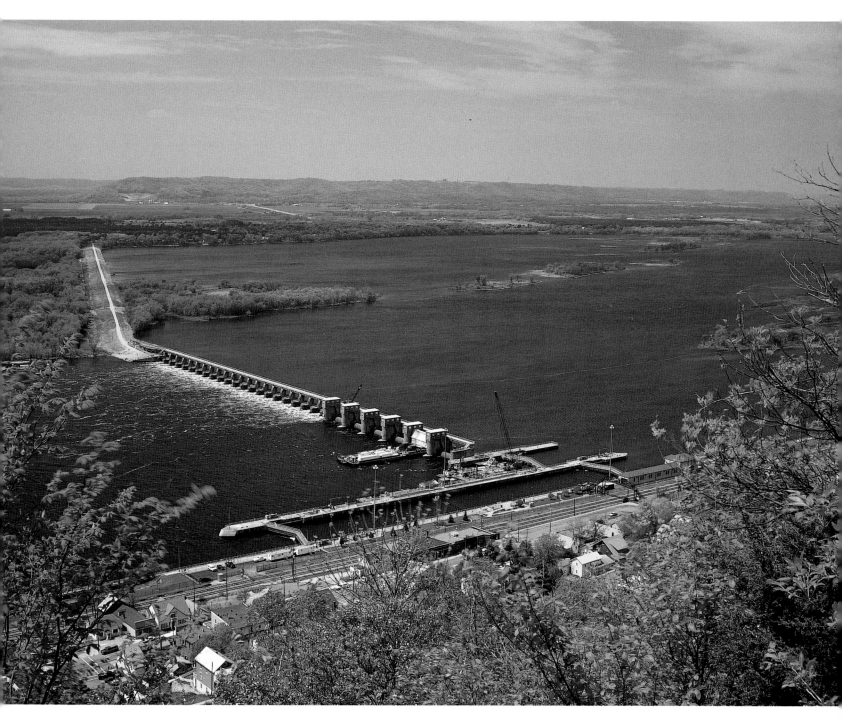

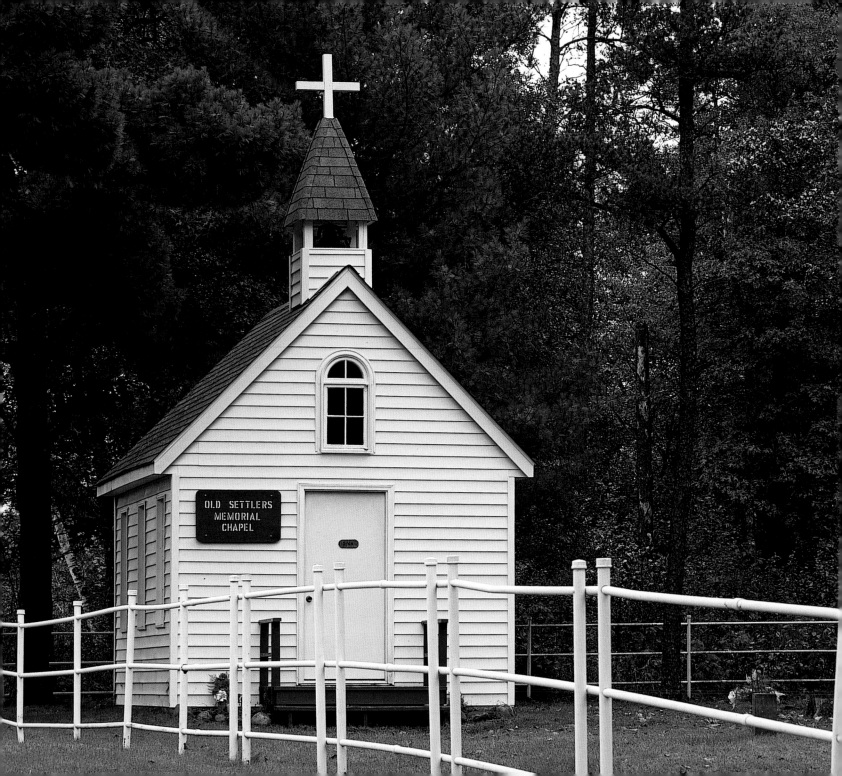

LEFT: An angler tries his luck in Lake Emily, part of 143-acre Lake Emily Park in Portage County.

FACING PAGE: Built by local citizens in the early 1880s, the Old Settlers Memorial Chapel in Polk County honors the area's first residents— many of whom are buried in the adjoining cemetery. The non-denominational chapel can be reserved for Sunday services, weddings, and other special events.

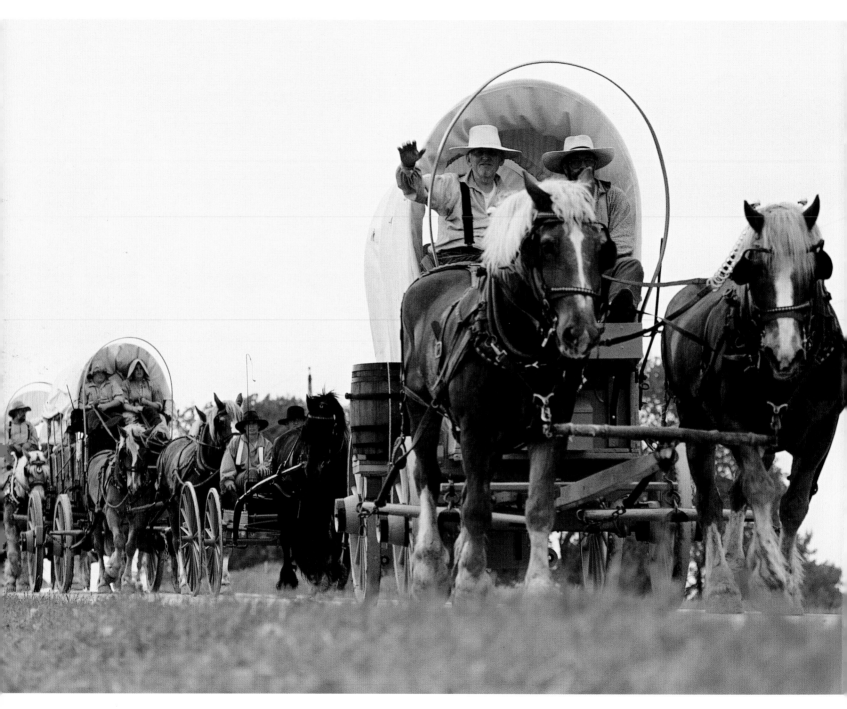

FACING PAGE: A pioneer wagon train rolls down a rural road in Kewaunee County. Honoring Wisconsin's past, re-enactors regularly participate in special historical events throughout the state.

BELOW: An Amish farmer plows his field in traditional fashion, with horsepower.

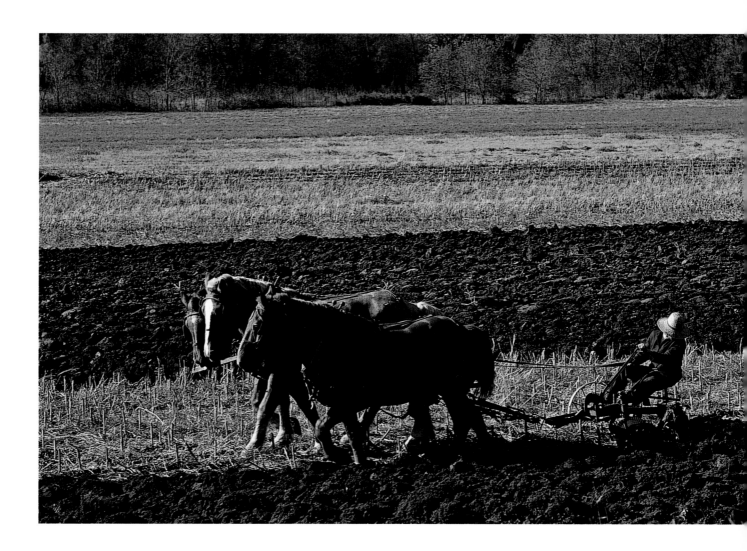

RIGHT: Adorned for the holiday season, the forty-foot, Cape Cod–design Lakeside Park Lighthouse is the crown jewel of Fond du Lac's 400-acre Lakeside Park.

FACING PAGE: Windblown icicles form at a surprising angle on the railings at Port Washington Harbor on Lake Michigan.

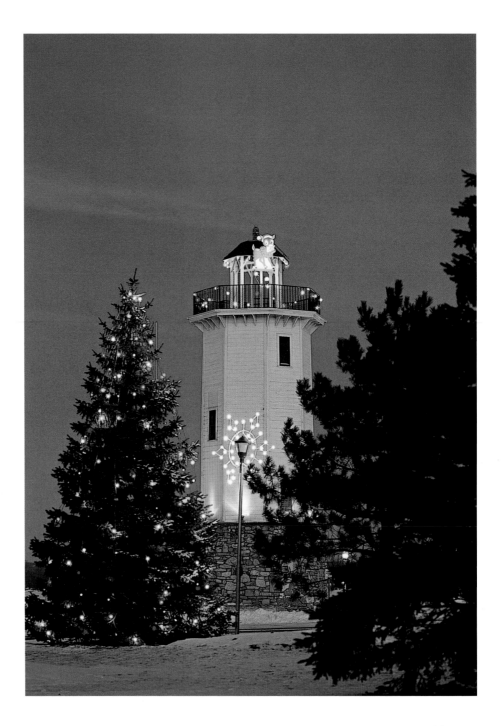

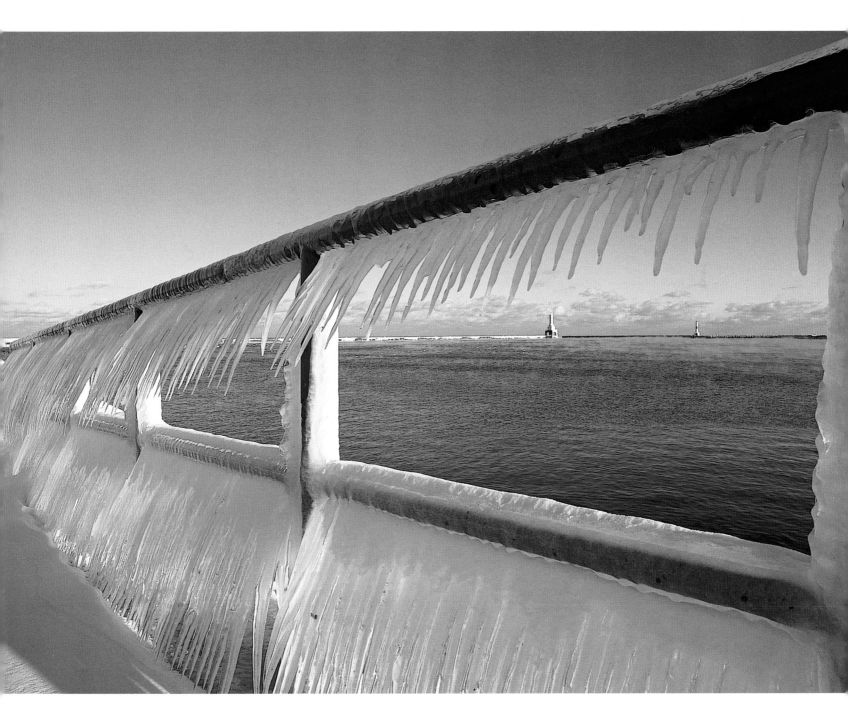

RIGHT: An angler casts his line into Lake Michigan at Sheboygan at sunrise.

BELOW: Every year, local firefighters lead a group of volunteers to Silver Lake to cut 3,000 one-foot blocks of ice, which they haul to Eagle River for use in constructing an ice palace, aglow with colored floodlights—a tradition since the 1920s.

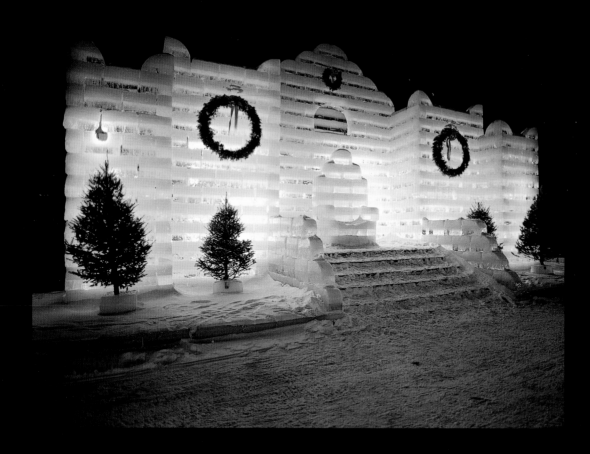

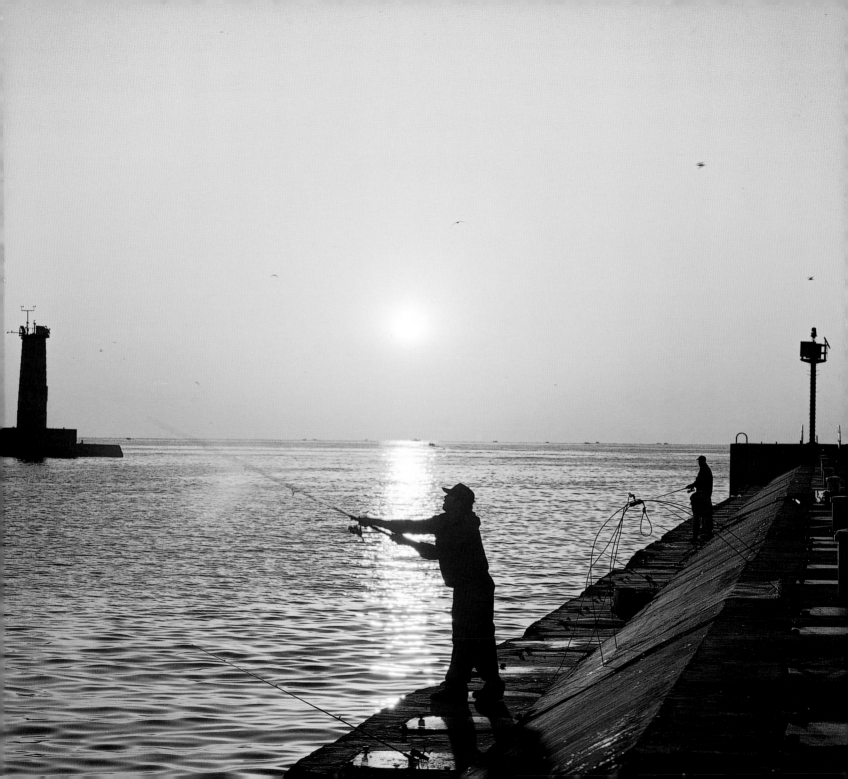

Darryl R. Beers

Darryl R. Beers was raised with a deep appreciation for the natural world that continues to shape his approach to photography. His images have received several regional, national, and international awards and have been published in numerous magazines, including *National Geographic Traveler, Country, Ducks Unlimited,* and *Sierra Club.* His images have appeared in many books and calendars, including those by such publishers as Abbeville Press, National Audubon Society, BrownTrout Publishers, and Reader's Digest. He was the sole photographer for the books *Michigan Impressions* and *The Spirit of Door County* and was a major contributor to *Wisconsin Simply Beautiful* and *Michigan Simply Beautiful.*